LEGENDAR

OF

OCEAN
CITY

NEW JERSEY

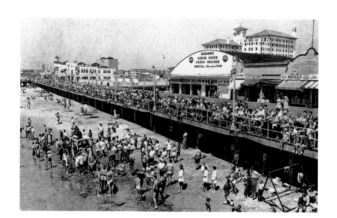

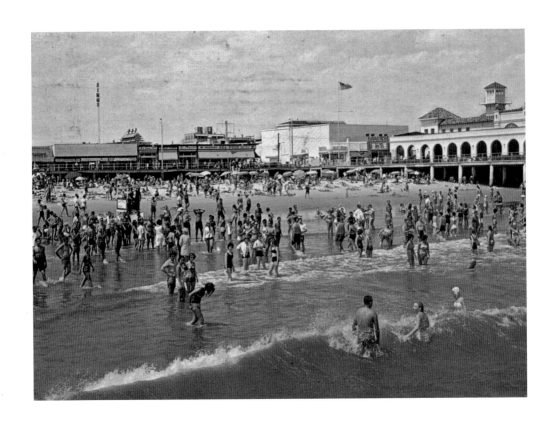

Page 1: Boardwalk Between 10th and 11th Streets
The 2.5 mile long boardwalk, with its shops, eateries, and amusements is always busy. The large arched building of Bingham's Kiddie Rides was first used at the 1939 New York World's Fair.

Page 2: Ninth Street Beach and Boardwalk
Music has long been important in Ocean City. The building on the right is the Music Pier at Moorlyn Terrace and the Boardwalk. It was designed by Ocean City native Vivian Smith and opened in 1929, replacing the older Music Pavilion. The Ninth Street beach, where this photograph was taken, is always one of the busiest beaches in town.

LEGENDARY LOCALS

OF

OCEAN CITY

NEW JERSEY

FRED AND SUSAN MILLER

*TO SONIA —
LOTS OF MEMORIES IN
THIS BOOK. ENJOY!
SEE PAGE 58.
Fred Miller 4-5-12*

LEGENDARY
LOCALS

Published by Legendary Locals, an imprint of Arcadia Publishing
Charleston, South Carolina

Printed in the United States of America

Library of Congress Control Number: 2011938418

For all general information, please contact Arcadia Publishing:
Telephone 843-853-2070
Fax 843-853-0044
E-mail sales@arcadiapublishing.com
For customer service and orders:
Toll-Free 1-888-313-2665

Visit us on the Internet at www.arcadiapublishing.com

On the Cover: From left to right:
(TOP ROW) Roland Gannon, aviator (Courtesy of Roland and Alberta Gannon; see page 63), Mark Soifer, public relations director (Courtesy of Mark Soifer; see page 116), Jeanne Clunn, councilwoman (see page 104), Henry Knight, mayor (Courtesy of Henry and Marie Knight; see page 115), George Lafferty, beach patrol captain (see page 98).
(MIDDLE ROW) Chester J.Wimberg, mayor (see page 101), William J. Hughes, congressman, ambassador (see page 110), Nicholas J. Trofa Jr. mayor (see page 112), Marla Adams, actress (see page 57), Howard S. Stainton, department store owner, philanthropist (see page 92).
(BOTTOM ROW) Marizita Grimes, teacher (Courtesy of Ocean City Historical Museum; see page 82), Grace Kelly and Prince Rainier, movie star, prince (see page 61), Gay Talese, author (see page 68), Angela and James Pulvino, county clerk, teacher (see page 100), Roy Gillian, amusement pier owner, mayor (see page 109).

CONTENTS

ACKNOWLEDGMENTS

We wish to thank Stu Sirott for his technical know-how and hard work, Susan's sister and brother-in-law, Joan and Allan Okin, for their editing skills, Sally Huff for her help and encouragement, and Mark Soifer for sharing his knowledge and photographs. Donald B. Kravitz and Edna Streaker May have generously provided photographs, as have so many others. The Ocean City Historical Museum (OCHM) has provided photographs and information. Unless otherwise noted, the photographs come from the authors' collection. We also want to thank our editor at Arcadia, Tiffany Frary, for her guidance in this endeavor.

We did our best to highlight individuals from various backgrounds in these 128 pages, but with a history as deep as Ocean City's, it was impossible to include everyone.

INTRODUCTION

Ocean City was founded in 1879 by five Methodist ministers who wanted to create a "Christian Seaside Resort." The reverends William H. Burrell, William B. Wood, and brothers Ezra, James, and S. Wesley Lake were aided by the Lakes' father Simon, who mortgaged his Pleasantville, New Jersey, farm to finance the venture. They bought up all of the properties on the island, so that they could place restrictions in the deeds prohibiting the manufacture or sale of alcohol and strictly regulating the forms of commerce and recreation allowed on Sundays. They created the Ocean City Association to govern the new community. The men moved their families to Ocean City and began the task of building not only a summer resort, but a fully functioning year-round community. They sold lots and encouraged craftsmen and businessmen of all kinds to come to the new town. Within a year, they had organized a railroad company and a daily ferryboat to the island. They built a school and a church, and organized water, electric light, and sewage companies. A weekly newspaper also began publication that first year. In some ways Ocean City has been progressive, but in other ways it has been slow to change. Women have owned and operated businesses here from the earliest days, but men had to wear tops on their bathing suits until 1949, the last municipality in the country to require them to do so. The restrictions on Sunday commerce were not lifted until a citizen-led referendum required it in 1986. African Americans have lived and worked in the city since the early 1900s, and the first African American lifeguard was hired in 1928, but the first female guard was not employed until 1976.In 1920, the Ocean City Chamber of Commerce adopted the slogan, "America's Greatest Family Resort," and that is still the city's motto today. Family has always been an integral element of the community. The Lake Family reunions draw hundreds of family members here each year. An orphaned boy came to his

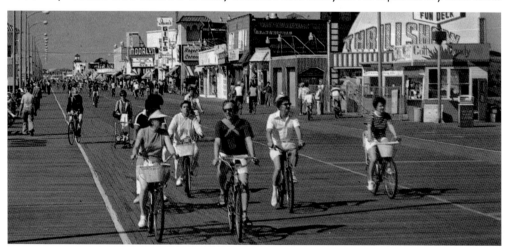

Biking on the Boardwalk
"Biking on the Boards" is one of the favorite activities for both locals and visitors. Bicycles are allowed on the boardwalk from 5:00 a.m. until noon during the summer season, all day and into the evening the rest of the year.

grandmother in Ocean City as a seven-year-old; he was embraced by the community and, as an adult, he was named Citizen of the Year. Many local families trace their roots back to the Lakes or other early settlers; many more have immigrated here from other countries or states. Some people have achieved great fame, while others are known only to their neighbors. All are part of the family of Ocean City. The community has not forgotten its roots as a Christian seaside resort. The founding fathers stipulated that building lots would be sold to church congregations of any denomination for a nominal amount of money. Today there are Catholic, Presbyterian, African Methodist Episcopal, Lutheran, Baptist, and nondenominational churches in the city. The Tabernacle Association—the religious arm of the Ocean City Association—still exists today. The nondenominational Ocean City Tabernacle takes up an entire block between Wesley and Asbury Avenues and Fifth and Sixth Streets. During the summer season, it functions as a church, bringing famous religious leaders to speak each Sunday. It also has a positive impact on the city at other times during the year when it opens its auditorium for citywide events, such as First Night Ocean City, allows the use of its parking area for antique car shows, and hosts groups in its newly built youth hostel. Another fundamental component of society here is education. The first school was started almost immediately in the Ocean City Association office; the first schoolhouse was built soon after. The community gives thousands of dollars in scholarship money to its high school graduates to help them further their educations. The high school building constructed in 1923 was in use over 80 years, serving students not only from the city but from surrounding smaller or more rural areas as well. In 2004, a beautiful new school was built that includes a large state-of-the-art auditorium used by the city as well as the school itself. Recreation for the resort's summer visitors as well as locals is important in a beach community. The city constructed a music pavilion on the boardwalk in 1905, and replaced it with the current Music Pier, on the boardwalk at Moorlyn Terrace, in 1929. There the Municipal Band provided free music; today the nationally known Ocean City Pops Orchestra entertains with low-priced concerts and guest performers. Every August, the city hosts the longest-running Baby Parade in the country with close to 100 children and parents participating in a walk down the boardwalk viewed by tourists and residents alike. The Gillian and Simpson families have operated two amusement piers on the boardwalk for many years. Kids from tots to adults enjoy the rides, games, and thrills at both all summer long. Generosity of time, of money, and of resources has always been important to the people of Ocean City. Burdette Tomlin spearheaded and helped fund the first (and only) hospital built in Cape May County. Howard Stainton allowed locals to "run a tab" for items they needed in the off-season and never charged them interest. He also donated land for the Ocean City Senior Center and the Wesley Manor Nursing Home. Stu Sirott devoted his time for nine years as the volunteer president of the Exchange Club's Family Center for the Prevention of Child Abuse. Many of the people in this book have been members of the police or fire departments or of the beach patrol. The city's administrators have always been aware of how essential public safety is to any area, and especially to a beach resort that hosts thousands of visitors each summer. The city first paid firemen in 1900, and the police department was organized in 1884. The lifeguards were first paid in 1898, only the second municipality in the country to do so. Other people have been involved in sports and youth athletic activities, and still others have been doctors, artists, or businesspeople who have seen a need or filled a niche and have, therefore, helped make this community what it is. These are the stories of the legendary people who have made Ocean City a great place to live, work, and play—truly America's greatest family resort!

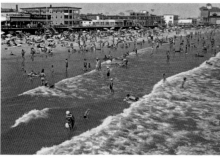

14th Street Beach
The 14th Street beach is one of the most popular bathing beaches. The authors met there in 1975 when Fred was working as a lifeguard.

CHAPTER ONE

A Vision Becomes Reality

In the 1700s and 1800s, the island that would become Ocean City was the summer camping grounds for the Lenni-Lanape tribe. The land was also used by some of the mainland people as a place to graze their cattle. The entire area was used by whalers as there were sheltering coves from which to work. The island's slanting beaches and numerous sandbars made it treacherous for ships, and many foundered along the shore. The custom at the time was that the first person to reach an abandoned ship could claim its cargo. In 1859, Parker Miller, employed as an agent of marine insurance companies, moved to the island to protect his employers' interests. Twenty years later, the Lakes, William Burrell, and William Wood, all Methodist ministers, looking for land to settle as a "Christian Seaside Resort," happened on the island and made it their own. Thus Ocean City was born. The men knew that for their community to prosper it was necessary to have year-round residents, and they encouraged others to settle here. They built schools, churches, and roads and provided the transportation and utilities needed to make the city an attractive place to live. They invited businesspeople of all kinds to join them in making Ocean City their home. These are the stories of those hardy people who settled Ocean City.

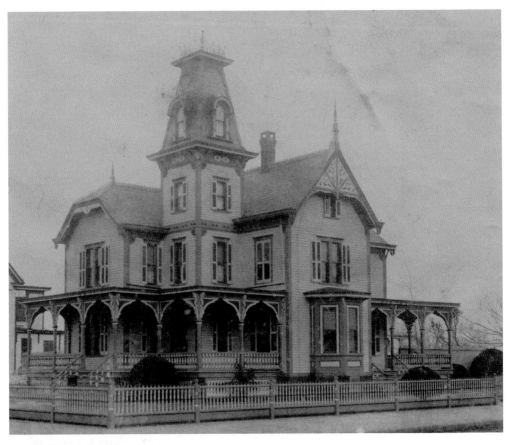

Ezra B. Lake

Founder Rev. Ezra B. Lake was the man most responsible for the city's early development. He was the first superintendent of the Ocean City Association, and soon had a schoolhouse and auditorium built, the city surveyed, the streets laid out and graded, and sewers constructed. He organized the electric light company, the trolley company, and the water company. This photograph is of his house, 435 Wesley Avenue. (Courtesy of OCHM.)

William H. Burrell

Methodist minister William H. Burrell, one of the founders of Ocean City, was elected as an Ocean City councilman in the city's first election in 1884. He made his home at 519 Fifth Street. He was known as the "marrying preacher" and his home was often called the "marrying house" because of the hundreds of weddings he performed there. Burrell was Ocean City's first postmaster, a position he held for six years.

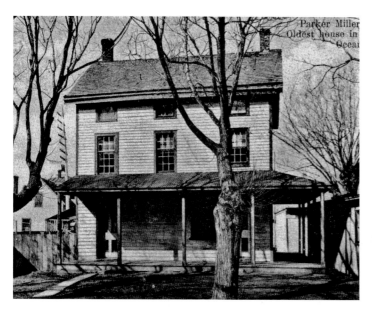

Parker Miller
The first person to settle on the island that was to become Ocean City was Parker Miller, an agent for marine insurance companies. He brought his family here in the 1860s. Miller claimed for his companies any ship that wrecked nearby and was abandoned by its crew. In 1884, he was elected to a seat on city council in the city's first election. Shown is his home at 726 Asbury Avenue.

Gainer P. Moore
Moore was the first person elected mayor after the city's incorporation as a borough in 1884. He served as mayor from 1884 to 1890, 1892 to 1894, and 1896 to 1897. Ocean City's Decoration Day (now known as Memorial Day) celebrations date to May 30, 1881, when Moore, a Civil War veteran, led a small group of men along Asbury Avenue to commemorate America's fallen soldiers.

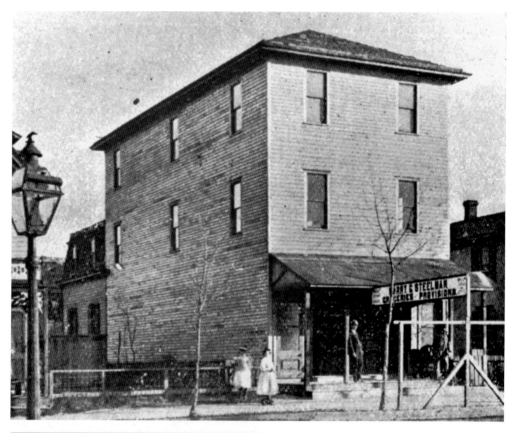

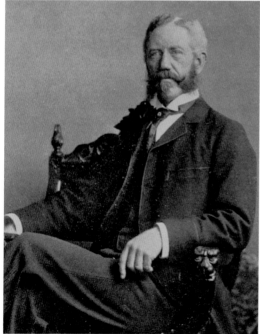

H.G. Steelman

Steelman came to Ocean City in 1888. In the 1894 mayoral election, he tied with Robert Fisher. Council chose Steelman as mayor, but he was only able to serve the first year of the term because Fisher went to court to contest council's choice. The court decided that Fisher would serve the second year of the two-year term. This photograph is of Steelman's grocery store at 705 Asbury Avenue. (Courtesy of OCHM.)

Robert Fisher

In 1879, Fisher came to the island. He worked for the Lakes surveying the town. He served one year as mayor after the contested 1894 mayoral election against H.G. Steelman. Neither Fisher nor Steelman was again elected mayor. Fisher later was elected to the city commission, where he served as director of the department of streets and public improvements.

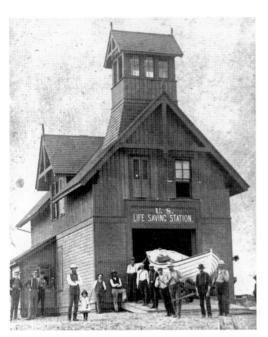

James Somers Willets

A captain in the U.S. Life-Saving Service, Willets was keeper of the Ocean City Life-Saving Station from 1877 to 1893. When he became keeper of the Ocean City Station, it stood at Fifth Street. In 1885, a new station was built at Fourth Street and Atlantic Avenue. During the time Willets was keeper of the station, he and his crew went to the assistance of 27 distressed vessels. This is a photograph of the newer station, built in 1885.

Joseph F. Hand

In 1890, architect and builder Joseph F. Hand designed and built the First Methodist Episcopal Church, shown below, at Eighth Street and Central Avenue, the first church built in the city. Elected to city council in 1893, Hand served in that position until 1901.

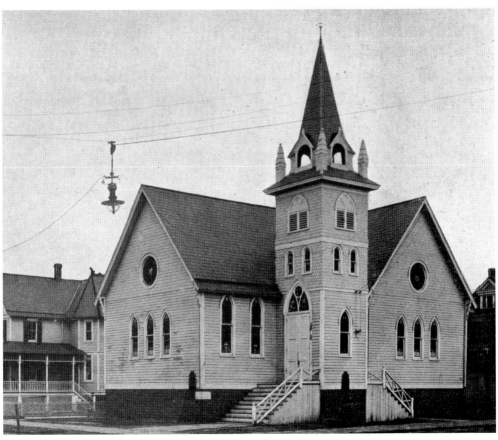

~1895~

...OCEAN CITY...

Guide Book and Directory

Ocean City, New Jersey.

...Containing a list of...
Permanent and Temporary Residents, Street Directory, Historical, Biographical and Descriptive Sketches, Wrecks, etc.

Mary Townsend Rush
Rush first wrote and published the *Ocean City Guide Book and Directory* in 1892. It was a list of permanent and summer residents, a street directory, and a directory of societies. It also contained biographical and historical sketches of Ocean City's citizens. Advertisements for the city's businesses make it clear that many women were active members of the community at that time: King's American Laundry was owned and operated by Mrs. Anna King, who offered "free delivery" and listed her prices; Mrs. B.F. Smith had a millinery store; Mrs. A.B. Ranck operated the Allaire Cottage and also had a fashionable dressmaking business with Miss Ida Taylor as her partner; and many women were listed as the proprietors of hotels and rooming houses. Rush continued publishing the *Directory* yearly until 1895.

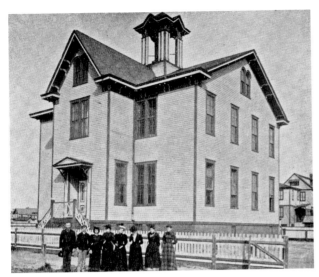

Leonard R. Thomas

Leonard R. Thomas was the principal of Ocean City's first public school, built in 1882 on Central Avenue, between Eighth and Ninth Streets. He introduced subjects into the curriculum that raised the standard of the educational system to the equal of any in the state. Thomas is on the left with his teachers, in front of the school.

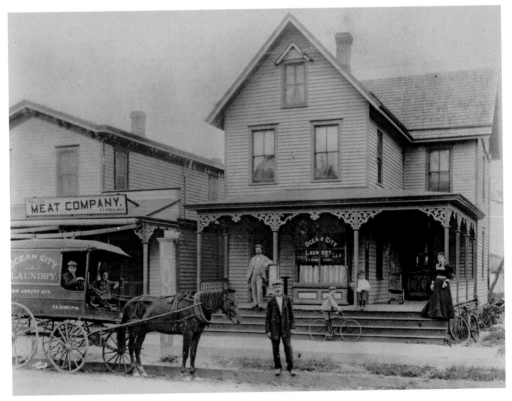

Frank E. Darby

Darby operated the Ocean City Laundry in 1895 with his wife Annie at 656 Asbury Avenue. In this photograph taken in front of the laundry stand Frank and Annie on the stairs and laundry wagon driver Hunter Thomas. The Darby children, Norman, Harry, Bertram, and Roy, are also in the picture. Bertram helped found the Ocean City Historical Museum. He was there in 1964 when the museum was opened in the old Wesley Avenue school building. (Courtesy of OCHM.)

Simon Lake

Lake, grandson of Ocean City founder Simon Lake, was the inventor of the even-keel submarine, one of the greatest contributions to the development of underwater craft. A photograph of him and his second submarine, the *Argonaut I*, launched in 1897, hangs in the National Museum of American History in Washington, DC.

J. Mackey Corson

Captain Corson succeeded James S. Willets as keeper of the Ocean City Life-Saving Station at Fourth Street and Atlantic Avenue in 1893 and served until 1911. He is in the center in this photograph with his 1898 lifesaving crew, from left to right, Melvin Corson, Townsend Godfrey, Philip S. Hand, William Garrettson, Enoch Clouting, Mulford Jeffries, and E.B. Campbell.

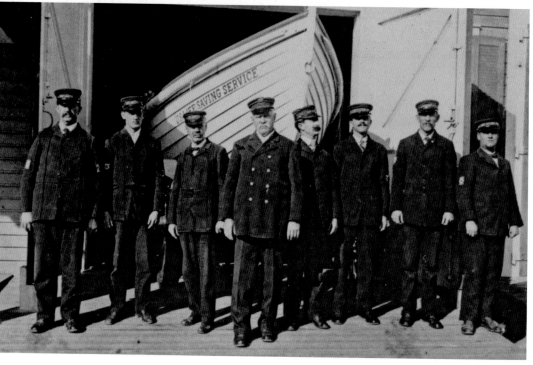

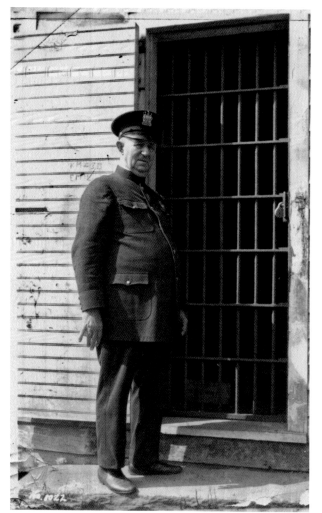

Samuel B. Scull
Samuel B. "Cappie" Scull was the chief of police from 1897 until 1923, when he took over the duties of desk captain. On November 8, 1927, Ocean City voters supported a measure that established a pension fund for the city's police and firemen. Scull was the first police officer to receive a pension when he retired. In this photograph, "Cappie" Scull stands next to the city's first jailhouse.

Liberty Fire Company
This 1902 photograph is of the Liberty Volunteer Fire Company. Edgar Ferguson is the driver and owner of the horses. The company was housed at 1219 Asbury Avenue. The company included Warren Brown, William H. Smith, Wilbur Ang, Emerson Smith, Nicholas Hickman, Somers Young, Frank Robinson, Fred Adams, John Trout, George Breckley, Charles Breckley, Samuel Smith, Clarence Ferguson, Leroy Jeffries, Jesse Stevenson, Joe Barclay, Harvey Morey, Vernon Carlson, and Horace Ang. (Courtesy of OCHM.)

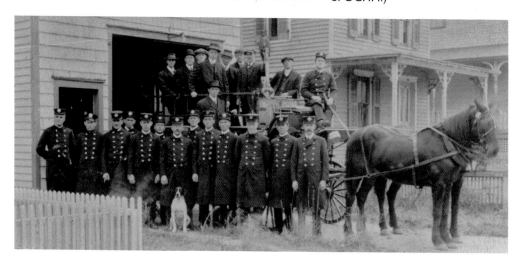

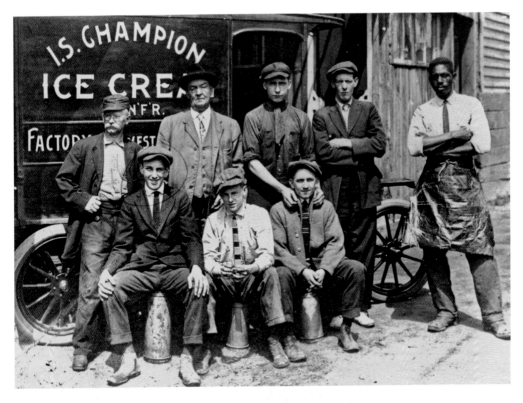

Ira S. Champion
In 1881, Champion established his ice-cream store on the corner of Seventh Street and Asbury Avenue. He also sold milk, cream, and eggs and had an extensive wholesale business. His ice cream was said to be the best in the city. In this photograph from 1907, Champion stands in the second row, left, with his staff. (Courtesy of OCHM.)

R. Curtis Robinson
Robinson was editor and owner of the *Ocean City Sentinel* and the *Ocean City Daily Reporter*. In 1888, he represented Ocean City on the Cape May County Board of Freeholders. In 1889, he was appointed postmaster, and, in that position, succeeded in having the mail service extended and the post office designated a money-order office. This photograph is of the *Ocean City Sentinel* building at 744 Asbury Avenue. (Courtesy of OCHM.)

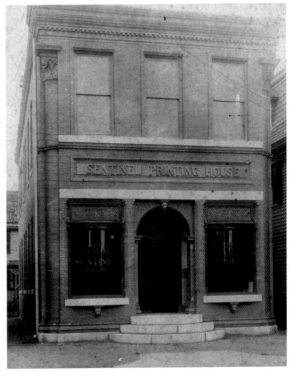

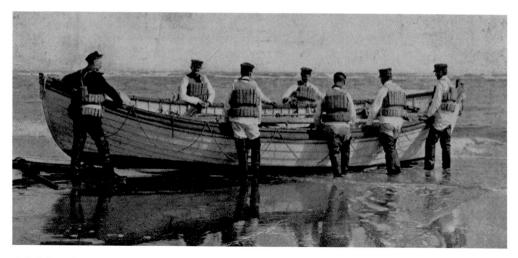

Adolphus C. Townsend

Captain Townsend served as keeper of the Peck's Beach Life-Saving Station at 36th Street from October 1900 until July 1916. The keeper of the station had a crew of seven men on duty with him from September through May, when storms were most active. During June, July, and August, he manned the station alone. Each keeper was responsible for a three-mile area: one-and-a-half miles on either side of his station. In this photograph, Townsend is on the left.

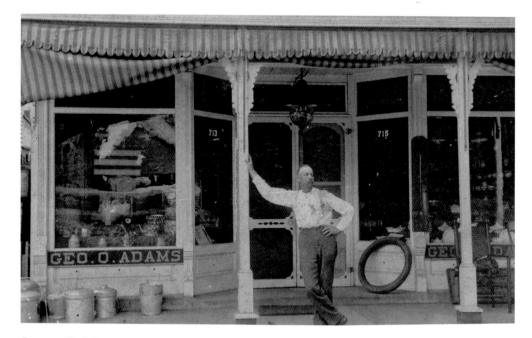

George O. Adams

In 1887, when the Ocean City Building and Loan Association was founded, Adams was named vice president. He was president of city council for four years, a city commissioner, member of the board of health, secretary of the school board for several years, and one of the organizers and first president of Volunteer Fire Company #1. Here he stands in front of his hardware store at 715 Asbury Avenue. (Courtesy of OCHM.)

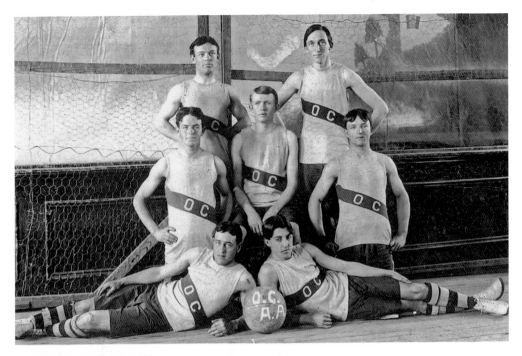

Ocean City Regulars

In 1903, basketball was a popular sport in Ocean City, and the local team was one of the best in South Jersey. The Ocean City Regulars were a group of young men who lived and worked in Ocean City and played as part of the Ocean City Athletic Association. In the photograph, left to right, bottom, are Oscar Morey and Art Chester; kneeling, Joe Morey, Jess Sterenson, and Charles Breckley; standing, Al Smith and Sam Schurch.

John W. Marts

Building contractor John W. Marts built hundreds of homes in the city, selling many of them directly to home buyers. President of city council when the city changed to a commission form of government in 1911, he was the only council member elected as commissioner. He was chief of the volunteer fire company before the paid fire department was organized.

R. Howard Thorn

Thorn was Ocean City's second postmaster, appointed on October 10, 1887. In 1889, he was elected to city council. He was again appointed postmaster on September 16, 1893. In 1911, Thorn was elected to the city commission, the first year elections for that position were held. A director of the First National Bank of Ocean City, he sits in the front row, right, in this photograph of the bank directors. (Courtesy of OCHM.)

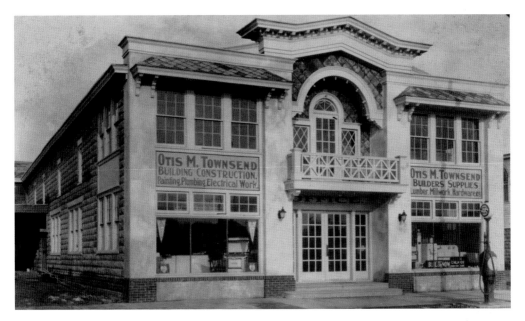

Otis M. Townsend

Townsend was instrumental in getting the first bridges connecting Ocean City and Somers Point, on the mainland, built. Three New Jersey governors blocked construction of the bridges before the Ocean City Automobile Company, of which Townsend was secretary, finally won approval to build them. He was a leading advocate for the bridges, which opened in 1914. Shown is Townsend's building at Eighth Street and Moore Avenue. (Courtesy of OCHM.)

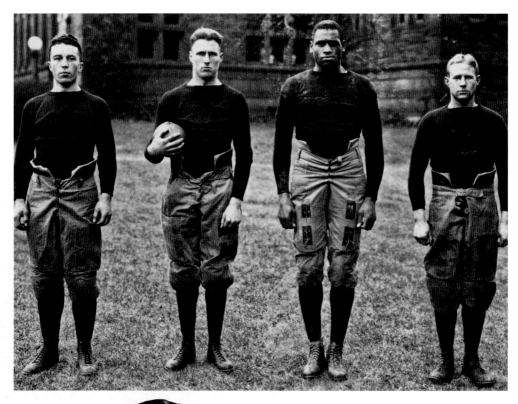

Joseph Breckley (ABOVE)
A 1914 graduate of Ocean City High School, Breckley was a starting end with Paul Robeson on the Rutgers College football team. Both men earned letters in baseball, basketball, and track as well as in football. Breckley went on to have a career in chemistry, his college major. Robeson went on to a career as a concert singer, recording artist, actor, and civil rights activist. In this photograph, Breckley is on the right with Robeson next to him.

Alfred R. Smith
Smith joined the Ocean City lifeguards in 1899 and was named captain of the guards in 1910, a position he held until 1920. He enlisted in the army in 1917 and received his commission as captain on October 26, 1918. He received an honorable discharge from the army on May 15, 1919, and returned as captain of the lifeguards that summer.

Luther L. Wallace and Sons
Wallace opened his hardware store in 1909. His sons, Hulings, left in the photograph, and Jonathon, right, joined him in the business. Hulings's son William, and William's wife Gladys, operated the store at 750 Asbury Avenue/751 West Avenue for several years. Now their children, Dave, Mike, and Dawn, the fourth generation of the family, are in charge. (Courtesy of Wallace family.)

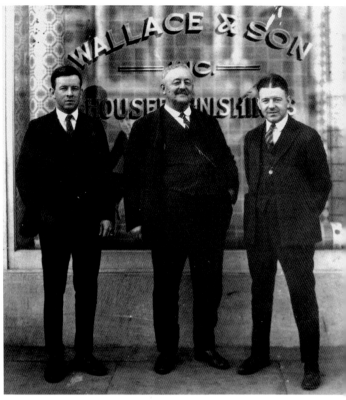

Lewis M. Cresse
President of the First National Bank of Ocean City, Cresse was elected to the state assembly in 1900 and was reelected in 1901 and 1902. In 1903, he became the first Ocean City resident to be elected to the New Jersey State Senate. He was mayor of Ocean City from 1907 to 1911. Cresse is shown here in his automobile in front of his home at Eighth Street and Wesley Avenue.

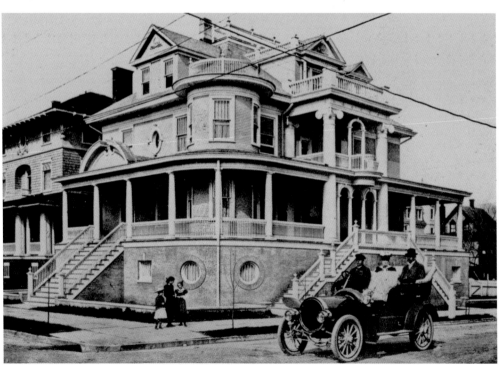

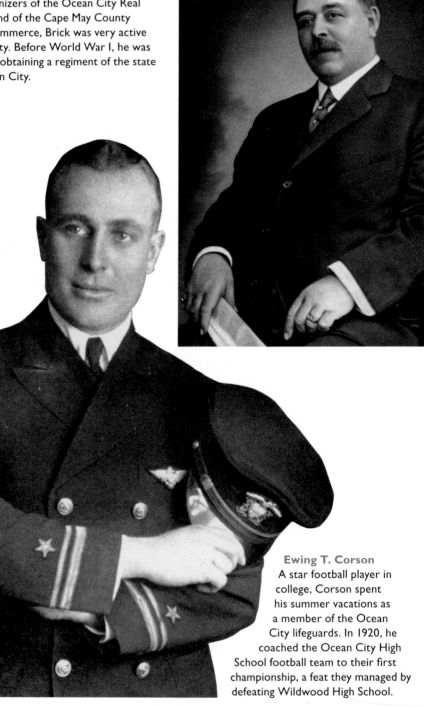

Clayton Haines Brick
President of the Ocean City Chamber of Commerce beginning in 1913, vice president of the Ocean City Title and Trust Company, one of the organizers of the Ocean City Real Estate Board, and of the Cape May County Chamber of Commerce, Brick was very active in the community. Before World War I, he was instrumental in obtaining a regiment of the state militia for Ocean City.

Ewing T. Corson
A star football player in college, Corson spent his summer vacations as a member of the Ocean City lifeguards. In 1920, he coached the Ocean City High School football team to their first championship, a feat they managed by defeating Wildwood High School.

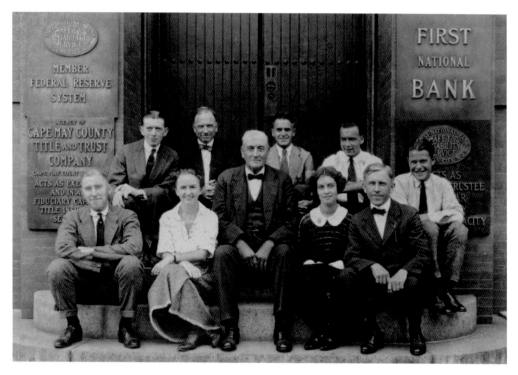

Richard B. Stites
In 1885, Stites opened R.B. Stites Company lumberyard on the corner of 12th Street and West Avenue. In 1900, he was elected to city council. He was a longtime member of the Ocean City school board and served as the first vice president of the First National Bank of Ocean City. In this 1921 photograph, Stites sits front row, center, with bank staff. (Photograph by W.H. Mowen, courtesy of OCHM.)

Hazel Marie Harris
The first Miss America Pageant took place in Atlantic City, New Jersey, on September 8, 1921. Miss Ocean City, Hazel Marie Harris, took home two prizes: third place overall and fifth place in the "bathers contest." She was a graduate of Ocean City High School and was teaching here when she entered the pageant. In this photograph, Harris is on the right.

1921 Board of Education

In 1920, America's women got the right to vote, and in 1921 Mayor Joseph G. Champion appointed the first woman to the board of education. Two male members immediately resigned. Mayor Champion, taken aback, appointed another woman as one of the replacements! In this photograph of the 1921 board of education, Eleanor Fogg is on the left and Josephine Goff is on the right. School superintendent James M. Stevens stands in the back row, center.

Vivian B. Smith

Smith was born in Ocean City in 1886 and attended Ocean City schools. An architect, he designed many of the city's most notable buildings: city hall in 1914; the Flanders Hotel in 1922; the high school in 1923; and the Music Pier in 1928. All of these buildings, with the exception of the high school, are still in use.

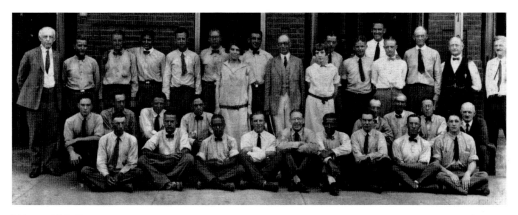

Edward M. Sutton
This photograph, from the summer of 1923, shows the entire staff of the Ocean City postal service in front of the US post office. Standing in the center, in the jacket, is Edward M. Sutton, postmaster from 1901 to 1914 and again from 1923 to 1928. James M. Stevens Jr., standing, sixth from right, son of longtime Ocean City school superintendent James M. Stevens Sr., was killed in World War II.

John Vincent Pontiere
Born in Italy but brought to America when very young, Pontiere and his brother Humbert gave the federal government a submarine that they had invented and built at their own expense. They considered it partial payment for the gift of US citizenship. In 1909, John Pontiere started the Seaside Construction Company, which built many of the homes in the Gardens section of the city. This photograph shows Pontiere and his wife.

27

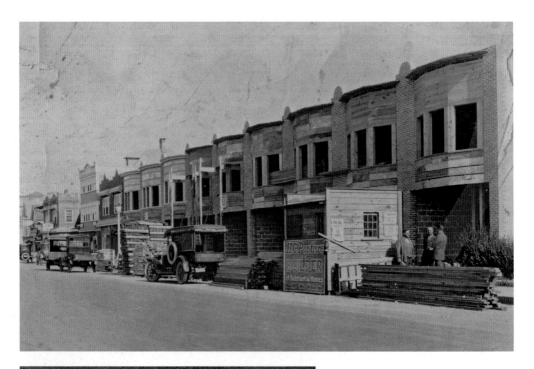

Humbert Pontiere

Home builder Humbert Pontiere, "Builder of Substantial Homes," had his office at 946 Asbury Avenue. In this photograph, taken in front of a row of houses Pontiere is building, Pontiere stands on the right, Frank Sannino is on the left, and an unidentified man is in the center. The homes are on the east side of Asbury Avenue between Ninth and 10th Streets. (Courtesy of OCHM.)

Otto W. Reichly

Reichly was the principal of Ocean City High School from 1915 to 1938. During his time as principal, the school population increased greatly and a new high school building was constructed on Atlantic Avenue between Fifth and Sixth Streets.

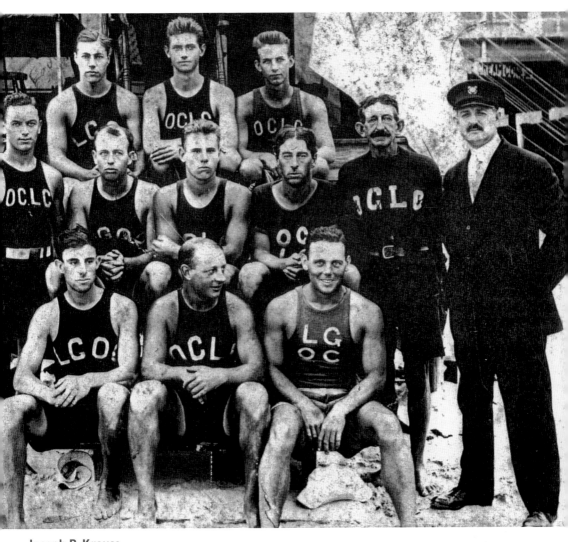

Joseph P. Krauss

An Ocean City lifeguard before the city paid lifeguards, Krauss, working for donations, began patrolling the beaches in 1893. In 1896, the *Ocean City Sentinel* led the demand for beach safety after two drowning deaths occurred in four days. It was not until August 3, 1898, however, that City Council finally voted to appoint three lifeguards. The city was the first municipality in Cape May County to pay for bather protection. Krauss was appointed captain of the lifeguard force, a position he held until 1910, with George W. Lee and William Scull working with him. The men were on duty from 9:00 a.m. to 3:00 p.m. and were paid $40 a month. In 1901, Krauss designed a lifesaving buoy used to aid struggling bathers. Krauss continued to work with the lifeguards until 1923. He stands second from right, second row.

Francis H. Ware

In the 1920s, female bathing suits were changing rapidly from loose-fitting wool dresses and stockings to tight-fitting knit suits with lower necklines. Many in the city were not happy with these changes, so during the summer of 1923 Judge Francis H. Ware, the police magistrate, was hired to walk the beaches to make sure women's bathing suits were not too revealing.

W. Ward Beam

Ocean City lifeguard W. Ward Beam was leading other lifeguards in calisthenics on the beach several mornings a week during the summer of 1920. As spectators watched his classes, many wanted to join in. By the following summer, Beam was leading classes on the beach for hundreds of people each morning. He continued holding the classes through the summer of 1929. In this 1923 photograph, Beam is in the front row with the megaphone during the Mid-Summer Revue on the 10th Street beach.

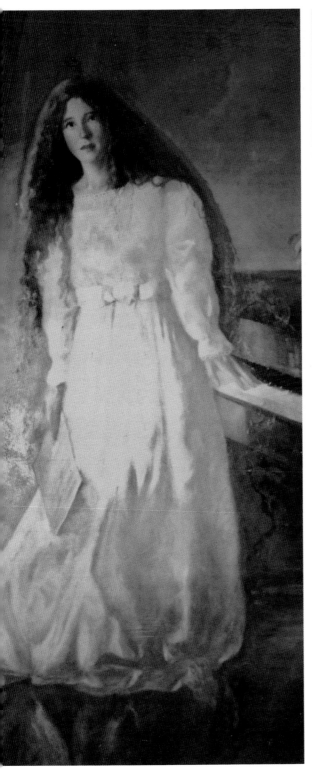

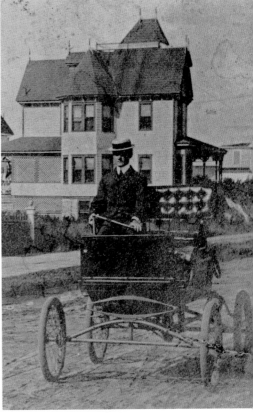

Harvey Young Lake

The ghost of Lake is said to be seen each year swinging his racket on the tennis courts in Ocean City. Harvey, the son of Ocean City founder S. Wesley Lake, was known as "Mr. Tennis." He helped persuade the city commissioners to build public tennis courts on Atlantic Avenue between Fifth and Sixth Streets in the early 1920s. In this photograph, Young is in his "Locomobile."

Emily, the Ghost of Flanders Hotel

The Flanders Hotel at 11th Street and Ocean Avenue opened in 1923, and soon after stories started circulating of a woman in white seen in the hallways and rooms where no one should have been. She is said to be able to walk through walls and has been heard singing in the hallways. She is called Emily, and her portrait is painted on the wall of a second floor hall in the hotel.

Elizabeth Blundin

In 1919, Blundin bought the Biscayne Hotel at 812 Ocean Avenue, and she managed it for over 60 years. She was one of the original members of the Hotel, Motel, and Restaurant Association, and served as its treasurer for many years. In September 1952, the hotel was destroyed by fire, but Blundin had it rebuilt and reopened in time for the following summer. This is an early photograph of the hotel.

James M. Stevens

Stevens was hired as the first school superintendent in 1903 and continued for 26 years. When he came to Ocean City, there was one school. During his tenure, three schools were built: the Central Avenue School in 1906; the Wesley Avenue School in 1913; and the high school in 1923. In this photograph, Stevens is in the center with school board members, Herschel Pettit, president, left, and J. Thornly Hughes.

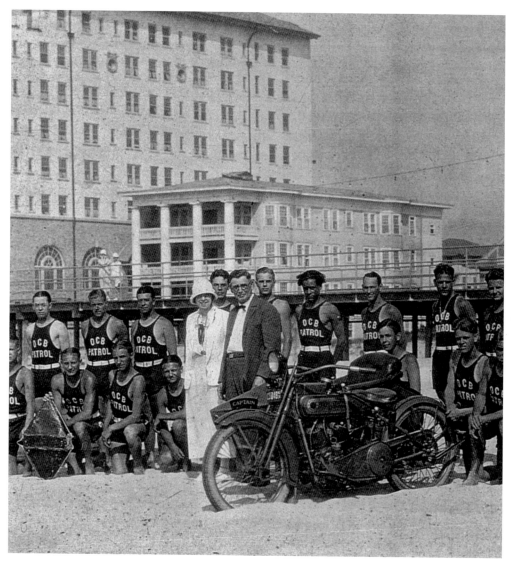

Marcia V. Smith

Marcia Van Gilder Smith, MD, was the first woman physician in Ocean City. She received her medical degree from the Women's Medical College of Pennsylvania in 1922 and opened an office at 621 Wesley Avenue, where she practiced until her retirement 50 years later. She was appointed beach surgeon on the Ocean City Beach Patrol in 1924, a position she held for many years. In 1933, she married Chris Montagna, owner of Chris' Restaurant and of a fleet of fishing and sightseeing vessels. Smith was known for the many humanitarian causes she supported, both locally and abroad. It was known in the community that Dr. Smith would see patients at any time, regardless of their ability to pay her. In 1959, she was named Woman of the Year by the Women's Division of B'nai B'rith. A small monument bearing her name was placed on a corner of the city park at Sixth Street and Ocean Avenue, as part of Marcia Smith Week on October 9, 1960, as a tribute from Israel for her dedication to that country. Also that year, Ocean City's chamber of commerce chose Smith as Outstanding Citizen of the Year. This 1924 photograph shows her in her role as beach surgeon, with Mayor Joseph Champion and members of the beach patrol.

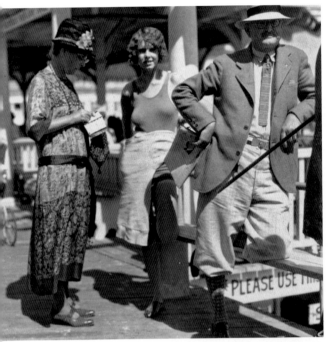

Lillian S. Olney

Olney spent the summer of 1925 patrolling the beach and boardwalk for underdressed patrons. She was hired as the first policewoman in Ocean City. Officer Olney acted as the beach and boardwalk censor. She was the busiest member of the police department, covering 2,525 cases during that summer.

Harry E. Shore

Officer Shore's name is on the National Law Enforcement Officers Memorial and the Cape May County Law Enforcement Memorial. Shore was an Ocean City patrolman when he was killed in the line of duty on July 29, 1927. He was rushing to respond to a call when the motorcycle he was driving overturned and threw him, causing fatal injuries. Officer Shore stands on the far left, third row, in this 1925 photograph of the Ocean City police squad.

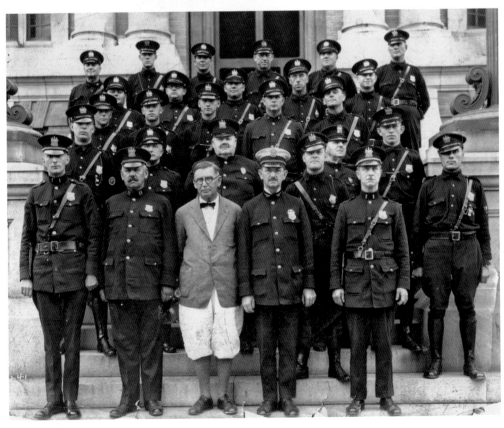

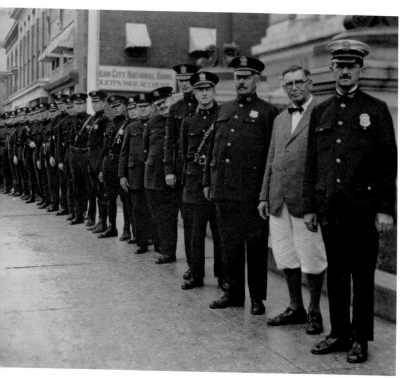

Howard T. Johnson Johnson was chief of the Ocean City Police Department from 1920 to 1931. He joined the United States Life-Saving Service as a young man and continued in the service until he was appointed to the Ocean City Police Department on June 7, 1912. On February 2, 1920, he was made chief of police. In this 1925 photograph of the department, Johnson stands on the right with Mayor Joseph G. Champion to his left.

Herschel Pettit While studying medicine in Philadelphia, Pettit spent his summers working on the trolley line in Ocean City. After receiving his medical degree, he moved here full time and opened his medical office in January 1912. He served on the Ocean City school board for forty years, from 1917 to 1932 and again from 1947 to 1972, many of those years as president. In this 1925 photograph, Pettit stands in the front row, second from left.

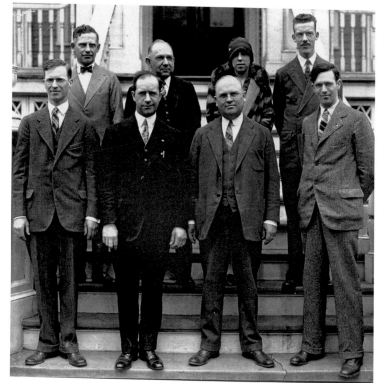

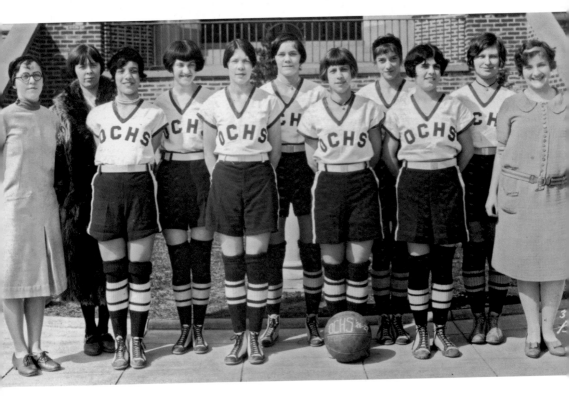

Miriam B. Reichly
The head of the girls' physical education department at the high school for many years, Reichly coached several of the girls' sports teams. In 1960, she was honored by the State Association of Health, Physical Education and Recreation for her many years of service in the field. Coach Reichly stands second from left in this photograph of the 1926-1927 basketball team. (Courtesy of OCHM.)

CHAPTER TWO

A Modern Resort Evolves

On October 11, 1927, a fire that may have started in a pile of trash beneath the boardwalk completely destroyed more than two blocks of the central city boardwalk and the surrounding stores and hotels, then moved up Ninth Street toward the downtown before it was halted. It took the combined efforts of the Ocean City Fire Department and those from communities as far as 30 miles away to bring it under control. The fire was so intense that burning embers were carried two miles across the bay to Somers Point, and flames could be seen lighting the sky for a radius of 25 miles. Fortunately there was no loss of life. What could have been a devastating setback to the community was instead the start of new prosperity. Joseph G. Champion, mayor at the time of the fire and for several years later, declared that, "The eyes of the country are upon us . . . the fire was a great loss, but in the end the municipality will be better off because of it!" His fighting spirit echoed those of the other citizens, and by the following summer the city had been rebuilt. The country went to war again and many of the community's men went off to fight. Those left behind, including the women, helped with the war effort in any way they could. After the war, the country slowly began to recover, and with it the community. With the opening of the New Jersey Turnpike and the Garden State Parkway, it became even easier to get to the resort, and businesses prospered.

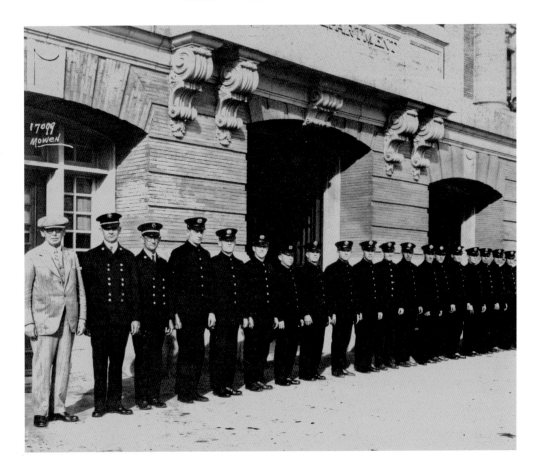

Joseph G. Champion

Champion began his political career with a humiliating defeat in the March 10, 1896 election when he received only 32 votes. But he ran again in 1901, and began an unparalleled 26 years as mayor. Champion was mayor from 1902 to 1907, 1915 to 1931, and 1935 to 1939. He also served several terms as county freeholder. An architect and builder, he saw the need to improve the city's infrastructure and did so: streets and alleys were hard-surfaced; after the devastating fire of 1927, the boardwalk was rebuilt with a fireproof concrete base; and the airport was built. Under his direction the Music Pier at Moorlyn Terrace and the Boardwalk, the Central Avenue School, and the high school on Atlantic Avenue were all built, and the Flanders Hotel was completed. In this photograph, taken in 1930 in front of city hall, Champion stands on the left with the fire department.

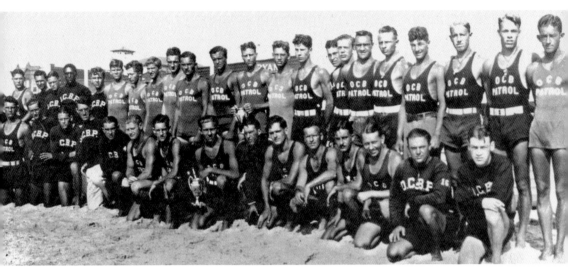

Alvin Thompson
The first African American lifeguard on the Ocean City Beach Patrol, Thompson served from 1928 to 1937. In this 1928 group picture, he stands fifth from the left. In August 1930, he was chosen Most Outstanding Guard of the Week by the Ocean City Real Estate Board and received a $10 reward.

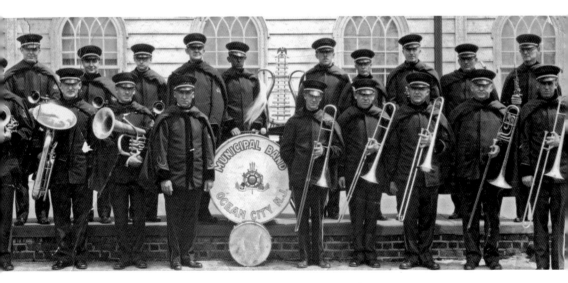

J. Fred Mann
Music had long been a mainstay in Ocean City when Mann directed the Municipal Band. In this photograph, taken May 15, 1929, before a Kiwanis Club dinner, Mann stands in the front row, left of the drum. In 1933, he organized a seven-man Music Pier orchestra, which soon expanded to 20 members. The free concerts, held nightly at the Music Pier, Moorlyn Terrace and the Boardwalk, were very popular with summer crowds. (Courtesy of OCHM.)

Samuel B. Conver
Conver joined Ocean City's volunteer fire company in October 1897 and was chief of the fire department from 1908 to 1938. He worked diligently to modernize the department. Not until July 1, 1930, almost three years after a fire had decimated parts of the boardwalk and downtown, did Chief Conver finally succeed in making the fire company a fully paid department.

Thomas F. Blake
Reverend Blake was the pastor of St. Augustine's Catholic Church from 1914 until 1944. Under his leadership, St. Augustine's School was opened on September 14, 1926. The first class, pictured here, graduated on June 12, 1929. In 1930, he commissioned the construction of a new church to be built at the corner of 13th Street and Wesley Avenue. The church was dedicated on June 28, 1931.

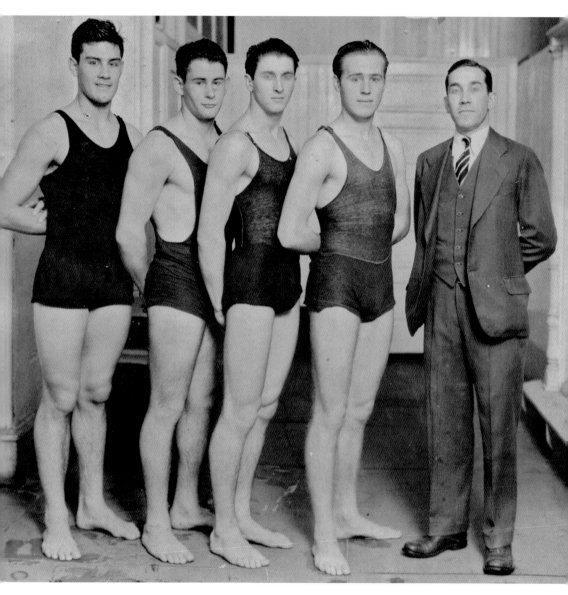

T. John Carey

The 1930 Ocean City High School swim team won the South Jersey championship by a wide margin. Standing are, from left to right, captain of the team T. John Carey, Olaf Drozdov, John Lawless, John Stubbs, and Coach Ray Fite. Both Carey and Drozdov worked as lifeguards during the summer, were champion rowers for the beach patrol, and are in the Ocean City Beach Patrol's Hall of Fame. Carey was an honors graduate of the University of Delaware and a lieutenant commander in the Navy during World War II, teaching survival tactics to pilots and air crews. He taught physical education and coached football, basketball, and track at Ocean City High School before leaving to take over the family's real estate business in 1947. In 1966, he received the city's Community Service Award for his efforts in establishing surfing as an organized sport.

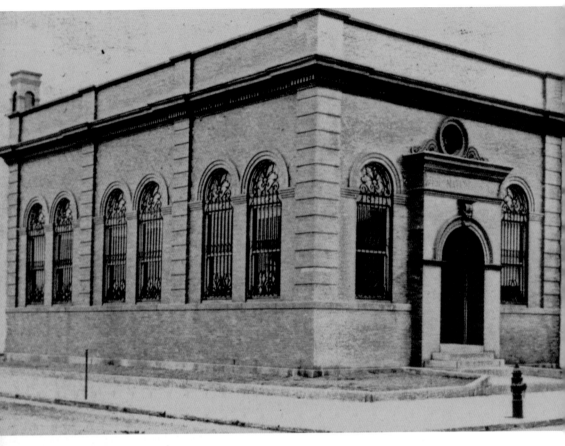

Harry Headley

Mayor of Ocean City from 1911 to 1915 and again from 1931 to 1935, Headley was first elected to city council in 1896 and was reelected in 1898, 1903, 1905, 1907, and 1909. In 1911, the city changed the form of government from seven councilmen and a mayor to a three-man commission. Headley, John Marts, and R. Howard Thorn were elected commissioners, and they chose Headley as mayor. A builder, Headley constructed the first brick building in the city on the northwest corner of Eighth Street and Asbury Avenue, where it still stands (photograph above). During his first administration, Headley decided the city needed a highway link with the mainland at Ninth Street, and a larger, more imposing city hall. The causeway to Somers Point, on the mainland, opened in 1914, and the new city hall, designed by Ocean City native Vivian Smith, in 1915 (bottom photograph, next page). After giving the citizens a tour of the new city hall, Headley and the commissioners were voted out in the election held four months later because, it was claimed, "City Hall cost too much." During Headley's second administration, four new concrete bridges were built between Ocean City and Somers Point. He was an important voice in the effort to establish the Ocean City Free Public Library in the high school and worked to solicit money to buy books and equipment. When the library opened in 1925, he was president of the board of trustees. The library was later named the Headley Memorial Library. In the top photograph, next page, Headley stands with a group of students on "Student Government Day." The students have just been installed as "Commissioners for a Day."

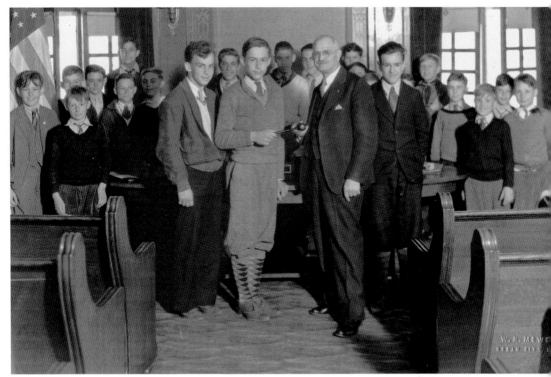

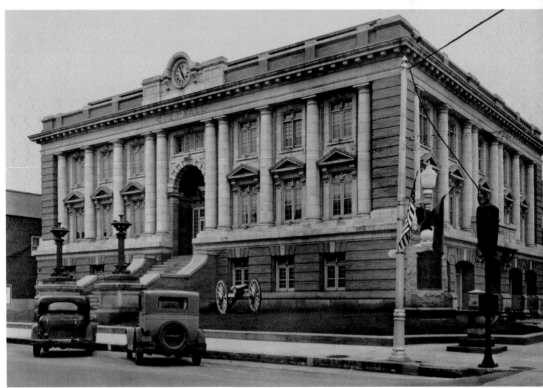

Samuel J. Comfort

Reverend Comfort, owner of the Hotel Comfort, shown above, was an early leader in Ocean City's African American community. He was one of the founding members of the Community, Civic, and Economic League of Ocean City, organized in 1930 for the mutual improvement of community life. On September 9, 1914, when Booker T. Washington came to speak at the First Methodist Episcopal Church, he stayed at the Hotel Comfort.

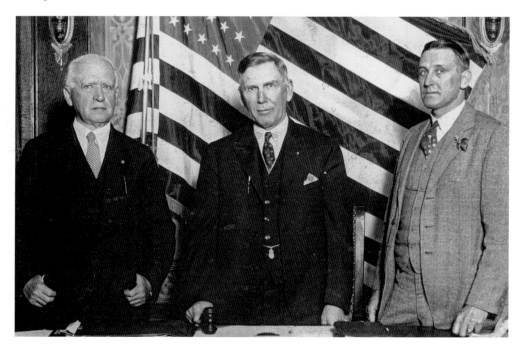

Reuben W. Edwards

On March 5, 1931, city commissioner Reuben W. Edwards paid tribute to the women of Ocean City and America in a moving speech asking the community to honor March 8–14, which had been designated National Business Women's Week. Edwards was commissioner of revenue and finance from 1927 to 1931. In this photograph, Commissioner Edwards stands on the left, with Mayor Joseph G. Champion in the center, and Commissioner John E. Trout.

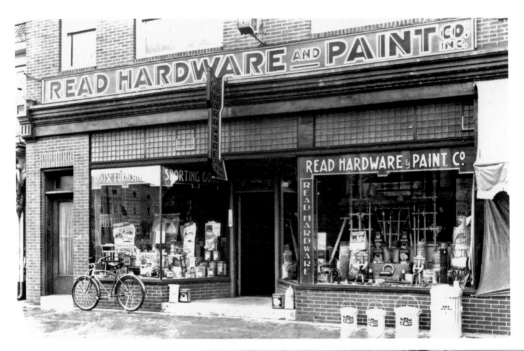

Charles C. Read
Read owned and operated a hardware and paint store at 852 Asbury Avenue. In 1927, he was elected state senator for Cape May County, a position he held until 1936. While a senator, he introduced a bill that transferred the meadows adjacent to the Somers Point Road from Upper Township, on the mainland, to Ocean City, giving the city control of one of its entrances.

Isaac Bacharach
Bacharach represented Ocean City in Congress from March 4, 1915 to January 3, 1937. As congressman, he was instrumental in getting the Ocean City–Longport Bridge built and was at its dedication on October 25, 1928. In this 1934 photograph, Congressman Bacharach, left, stands with Mayor Harry Headley, center, and Harold G. Hoffman, commissioner of the New Jersey Motor Vehicle Department. (Courtesy of OCHM.)

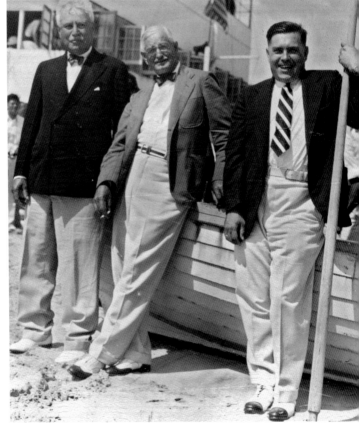

45

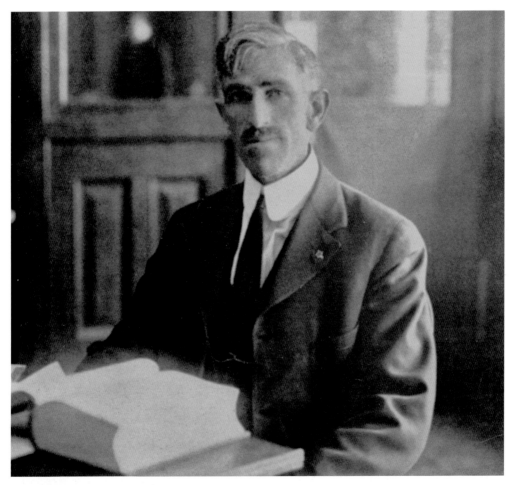

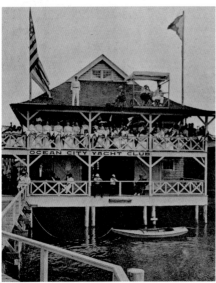

Andrew Cottrell Boswell

Admitted to the New Jersey Bar on June 1, 1900, Boswell opened his law practice here that same year. A star baseball pitcher in college, he was one of the men responsible for starting a municipal baseball team. In 1901, he represented the Holiday Boating Club when it was incorporated as the Ocean City Yacht Club. Boswell was city solicitor from 1915 to 1936 and was recognized throughout the state as an expert in municipal law. His son, John Edward Boswell, born in Ocean City on May 10, 1905, graduated from Ocean City High School in 1924. Young Boswell was the first Ocean City native to be admitted to the bar. The two practiced law together, and John succeeded his father as the city's solicitor. In 1937, John was elected to New Jersey's General Assembly and was reelected for five more terms. The top photograph is Andrew Cottrell Boswell. The bottom photograph is the Ocean City Yacht Club.

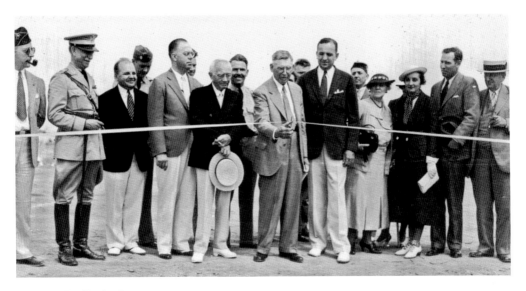

Vincent A. Clarke Jr.
Ocean City resident Vincent A. Clarke Jr. was the commander of the *Los Angeles*, the navy's 670-foot-long dirigible. Clarke often flew his airship over Ocean City and would dip its nose as he passed over his father's machine shop on Bay Avenue. In this photograph, Vincent A. Clarke Sr., holding straw hat, stands with Mayor Joseph G. Champion at the opening of the Vincent A. Clarke Jr. Municipal Airport on July 4, 1935. (Courtesy of OCHM.)

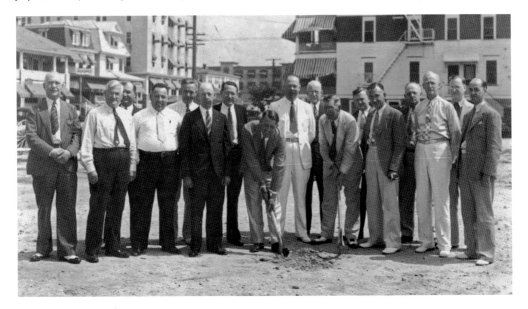

Leroy Jeffries
Jeffries was postmaster of the Ocean City Post Office from 1936 to 1954. In 1936, he negotiated a deal whereby the federal government paid $45,000 for a lot on the northeast corner of Ninth Street and Ocean Avenue. In 1937, the post office moved there from 410 Eighth Street. It opened for business on Monday, June 28, 1937. In this photograph of the ground breaking, Postmaster Jeffries wields the shovel on the left. (Courtesy of OCHM.)

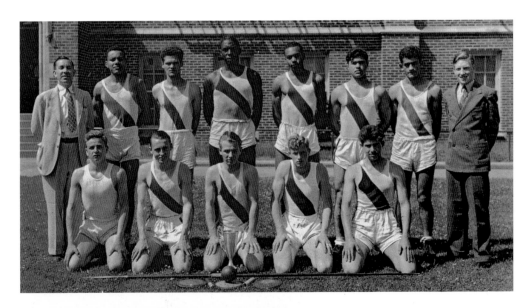

Archie Harris

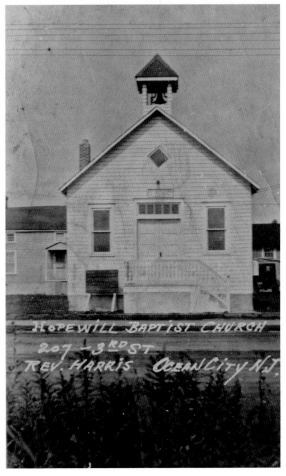

Harris was a football, basketball, and track star at Ocean City High School, class of 1937. He was a senior at the University of Indiana when he broke the world discus record in 1941 with a toss of 174 feet 8 3/4 inches in an NCAA meet. There is no question that Harris would have participated, probably successfully, in the 1940 and 1944 Olympic Games, but they were not held those years because of World War II. Harris spent his summers as a lifeguard on the Ocean City Beach Patrol. After graduating from Tuskegee Flight School, he flew 10,000 hours as a bomber pilot with the 617th Bombardment Squadron. After the war, he joined the physical education staff of the Harlem YMCA. Harris's father was pastor of the Hopewell Baptist Church at 205 Third Street. In this 1937 photograph of the Cape May County Championship Track team, Harris stands fourth from left in the back row, and Roger LaRosa stands third from right. (Courtesy of Roger LaRosa.) The bottom photograph is of Harris's father's church.

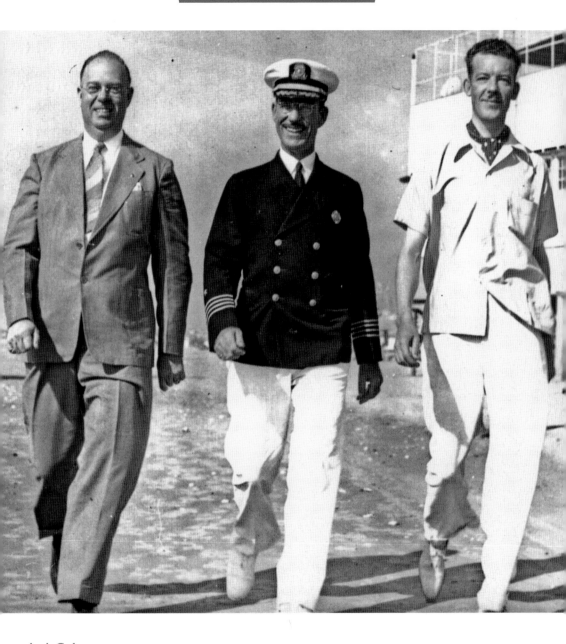

Jack G. Jernee

Jernee was appointed captain of the Ocean City Lifeguards in 1920, and one of the first things he did was change the name to the Ocean City Beach Patrol. He used the experience he had gained from his years in the United States Life-Saving Service and the US Coast Guard to build the beach patrol into one of the finest lifesaving squads in the country. Jernee led the beach patrol until 1942, when he left for service with US Navy Intelligence during World War II. From 1933 to 1935, he was also the chief of the Ocean City Police Department. He started the city's annual Easter Egg Hunt and is credited with reviving the Night in Venice boat parade as an event for the city's 75th anniversary in 1954. In this 1939 photograph are, from left to right, Mayor George D. Richards, Jernee, and beach surgeon C. Eugene Darby, MD.

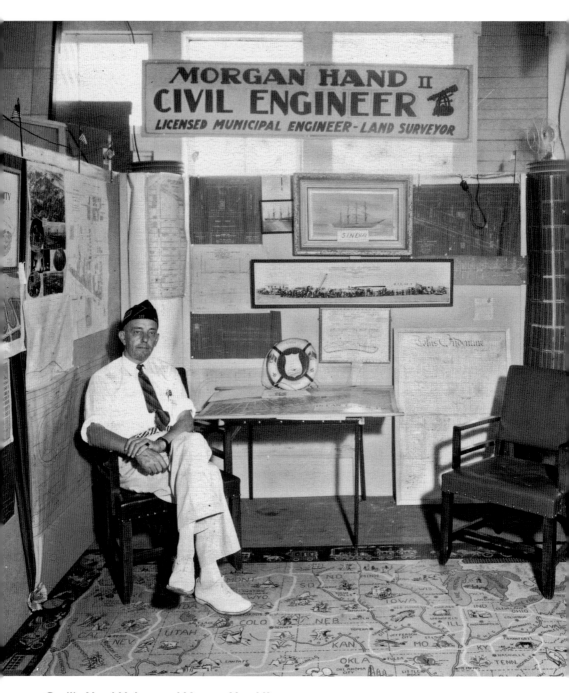

Cecilia Hand Nelson and Morgan Hand II
Cecilia Hand Nelson and her brother, Morgan Hand II, traced their family back to Cape May County's earliest settlers. She was a librarian for the Ocean City Public Library and one of the founders of the Ocean City Historical Museum. He was one of Cape May County's most prominent engineers and a charter member of the Cape May County Historical Society. This is a photograph of Hand taken during the American Legion Home and Appliance Show in 1939. (Courtesy of OCHM.)

Lura and Hiram B. Whitaker
Married for over 65 years, Lura and Hiram B. Whitaker operated a confectionery and ice-cream store at 3346 Asbury Avenue. Whitaker enlisted in the United States Life-Saving Service and served for six years before they opened their store. He was stationed at the Corson's Inlet Life-Saving Station in 1901 when the *Sindia* wrecked on the 17th Street beach, and he assisted in the rescue of the crew. (Courtesy of Clinton Campbell.)

Burdette Tomlin
Discussion about building a hospital in Cape May County began in the 1930s, but not until Ocean City resident Burdette Tomlin deposited $25,000 in the First National Bank of Cape May Court House to seed a building fund on May 5, 1941, did the talk get serious. Tomlin, owner of the Silica Sand Company, stipulated that his money was to be refunded if it was not matched by November 1, 1941. He also required that the hospital be nonpolitical, for all races and creeds, and that it be located within one mile of the intersection of Main and Mechanic Streets in Cape May Court House. Tomlin died before the November 1st deadline, but people had responded to his call, and Burdette Tomlin Memorial Hospital opened on October 9, 1950. Enlarged several times, it is still the only hospital in Cape May County.

Robert L. Monihan
Robert L. Monihan founded Monihan Realty in Ocean City in 1947. In 1976, he was honored by the Ocean City Board of Realtors as Realtor of the Year. As a young man, Monihan was a champion swimmer, representing the Ocean City Beach Patrol in South Jersey, state, and national competitions. His father, son, and grandson also swam as members of the patrol. In this 1938 photograph, he sits with his sister, Anne, in a lifeguard stand.

George D. Richards
An attorney who had graduated from the New Jersey School of Law, George D. Richards was mayor from 1939 to 1943. He first entered public life as the police magistrate, where he won acclaim for his efficient handling of the police court. In this 1933 photograph of the police department, he stands in the front row, third from left, with, from left to right, police chief Jack Jernee, mayor Harry Headley, and police captain Robert Lackey. (Courtesy OCHM.)

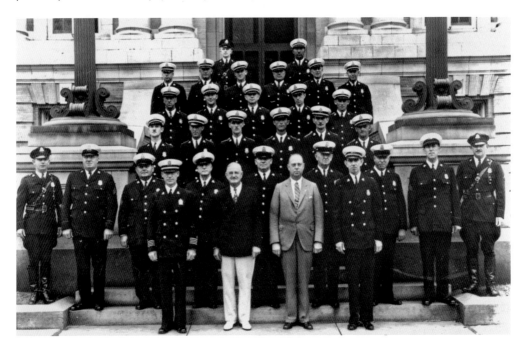

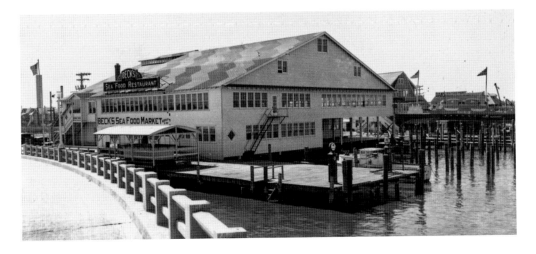

Beck's Seafood Restaurant
Beck's Seafood Restaurant, "As You Enter Ocean City at the Bridge," began in 1928 as a small stand selling fresh seafood. By 1937, it was advertising that it had served "47,759 patrons in July and August of 1936," and it was the largest seafood restaurant in Ocean City. Fishing boats delivered fresh catches to the restaurant every day.

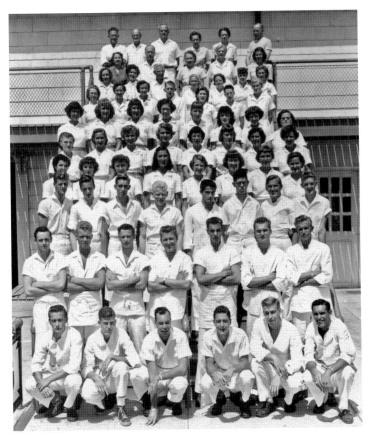

Hogate's Restaurant
Hogate's Seafood Restaurant began as Beck's in 1928. In 1939 the restaurant's new owner, Ocean City physician John Hogate Whiticar, changed the name to Hogate's. It was the largest restaurant in the city. The restaurant was closed after the summer of 1972, and the property was sold with plans for a luxury motel, restaurant, and retail stores. However, condominiums were built there instead. This 1949 photograph showing the staff was taken in front of the restaurant. (Courtesy of Bernice Delaney.)

Hobo

Hobo, Ocean City's beloved mascot, reportedly was found in a snowdrift during the 1920s. During the summer, the boardwalk restaurants fed him and the tourists pampered him. He had a special fondness for ice-cream cones and would sometimes lie on the boardwalk playing dead until someone held a cone in front of his nose, which never failed to instantly resurrect him. In the winter, he moved downtown and was a welcomed guest at restaurants there, sometimes finding shelter at the Fourth Street Coast Guard Station. He was petted and loved by the locals, especially the children. When Hobo died on December 8, 1936, schoolchildren raised money for a memorial, which stood for many years on a corner of the high school grounds. It now stands outside the Community Center at 17th Street and Simpson Avenue. (Photograph of Hobo courtesy of Edna Streaker May.)

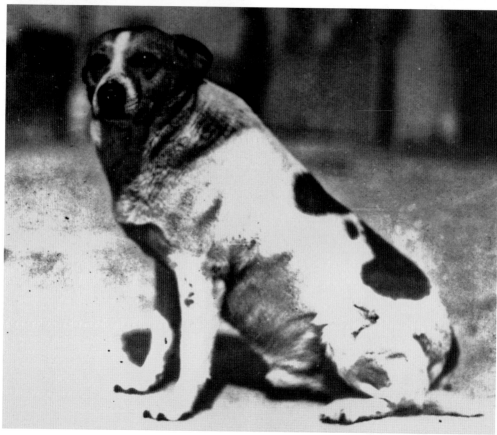

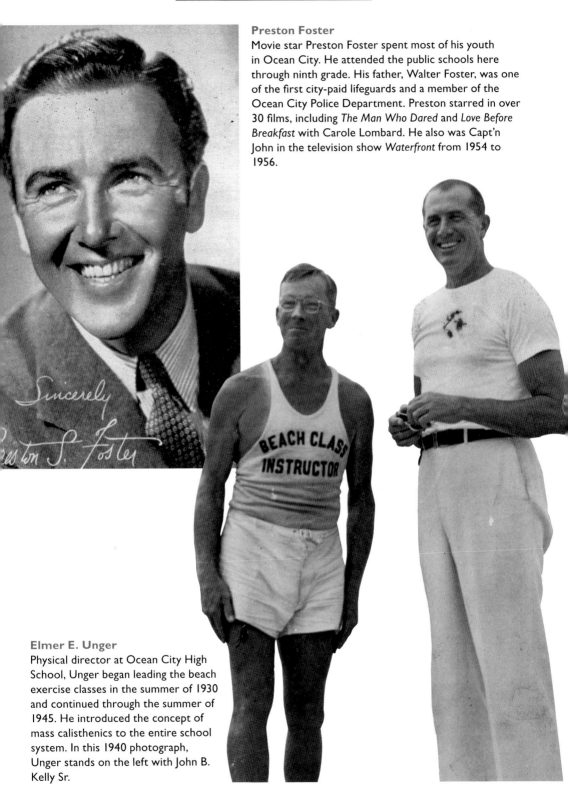

Preston Foster

Movie star Preston Foster spent most of his youth in Ocean City. He attended the public schools here through ninth grade. His father, Walter Foster, was one of the first city-paid lifeguards and a member of the Ocean City Police Department. Preston starred in over 30 films, including *The Man Who Dared* and *Love Before Breakfast* with Carole Lombard. He also was Capt'n John in the television show *Waterfront* from 1954 to 1956.

Elmer E. Unger

Physical director at Ocean City High School, Unger began leading the beach exercise classes in the summer of 1930 and continued through the summer of 1945. He introduced the concept of mass calisthenics to the entire school system. In this 1940 photograph, Unger stands on the left with John B. Kelly Sr.

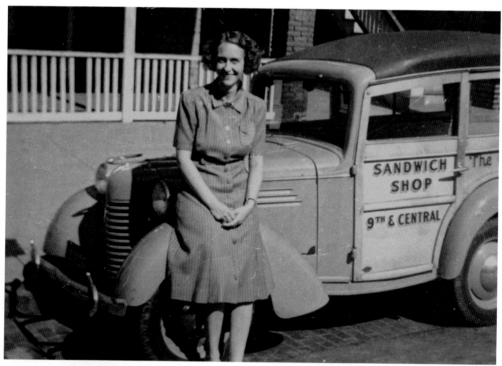

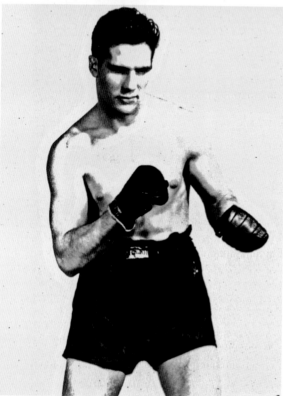

Jean Campbell

In 1937, Campbell (pictured in 1941 in front of her delivery truck) opened the Chatterbox Restaurant on the northeast corner of Ninth Street and Central Avenue. A few years later, she moved across the street to the southeast corner into a Spanish Mission Revival building designed by Ocean City native Vivian Smith. Although Campbell sold the restaurant in 1960, the Chatterbox still stands as a landmark. (Courtesy of OCHM.)

Billy Conn

Conn was the light heavyweight champion of the world, but he admitted that what he really wanted to be was an Ocean City lifeguard. He was named Fighter of the Year by *Ring* magazine in 1940. In 1941, he relinquished his title to move up to heavyweight and fight Joe Louis. The two met in New York City on June 18, 1941, and after beating Louis in the first 12 rounds, Conn was knocked out with two seconds to go in the 13th. The next day, he drove to Ocean City, picked up Mary Lou Smith, and the two eloped.

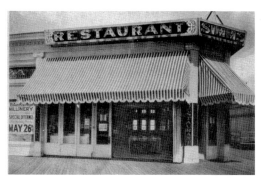
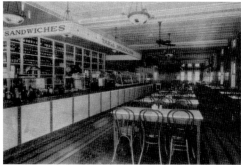

Floyd Simms

Simms opened Simms' Seafood Restaurant on the Boardwalk at Moorlyn Terrace in 1912 and remained in charge until his semi-retirement in 1952, when his son Jim took over. The restaurant, with stained-glass windows, hand-painted chandeliers, sticky cinnamon buns, and sumptuous seafood platters, was an Ocean City landmark for generations of visitors.

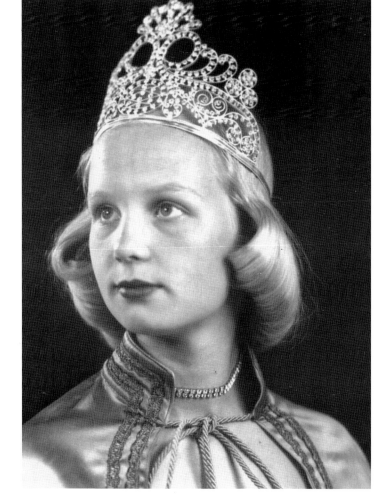

Marla Adams

Born August 28, 1938, in Ocean City, Adams attended the American Academy of Dramatic Arts in New York City. She was in the 1958 Broadway play *The Visit* and in the 1961 movie *Splendor in the Grass*. She also starred in several television soap operas: as Belle Clemons in *A Secret Storm* (1968–1974), Dina Abbott Mergerson in *The Young and the Restless* (1983–1986), and Beth Logan in *The Bold and the Beautiful* (1991).

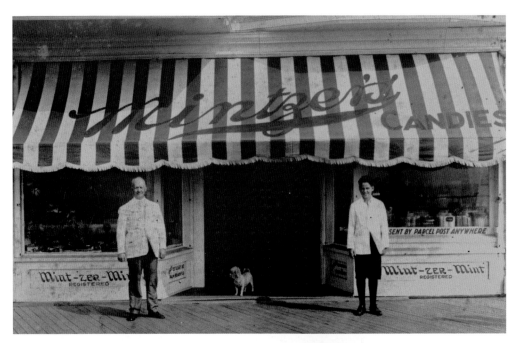

Mintzer's Mint Shop
Lynwood F. and Inez Mintzer, shown in this photograph, owned Mintzer's Mint Shop at 946 Boardwalk, where they manufactured their own brand of candy. The Mintzers had four children: Margaret, twins Lynwood F. and John, and Donald. All three sons were members of the beach patrol. Lynwood Jr. followed his father into the candy business. John was one of the last soldiers killed in Germany in 1945. (Courtesy of OCHM.)

C. Douglass Longenecker
In 1924, Longenecker opened Douglass Candies, a wholesale and retail candy store at 700 Boardwalk. He had started in the candy business with his uncle, Charles A. Douglass, in Wildwood, New Jersey, after his service as an aviator during World War I. Until Longenecker closed the store in 1955, Douglass Candies was one of the most popular candy stores on the boardwalk. (Courtesy of Douglass Longenecker.)

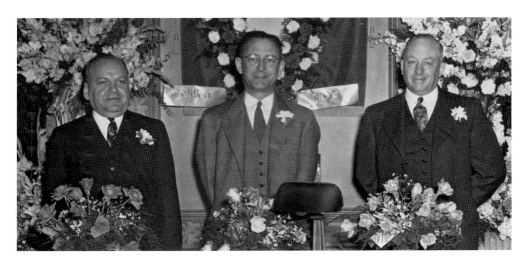

Clyde W. Struble

From left are Henry Roeser Jr., Clyde W. Struble, and Edward Bowker, at their installation as city commissioners on May 18, 1943. At their organization meeting, Struble was chosen mayor. He promoted the idea of the county, state, and federal governments sharing the cost of beach erosion control. A big supporter of the beach patrol, Struble, with Beach Patrol captain Tom Williams and John B. Kelly Sr., revived the South Jersey Lifeguard Championships in 1944. (Courtesy of OCHM.)

Norman V. Sargent

Dr. Norman Vincent Sargent was the city publicity director. In 1943, he had this photograph taken of, from left, Clyde W. Struble, mayor; Dr. Sargent; Edward Bowker, city commissioner; and Henry Roeser Jr., city commissioner. He sent the picture to newspapers in the area with the following statement: "Gasoline shortage does not deter the city commissioners from making an official inspection of the resort." (Courtesy of OCHM.)

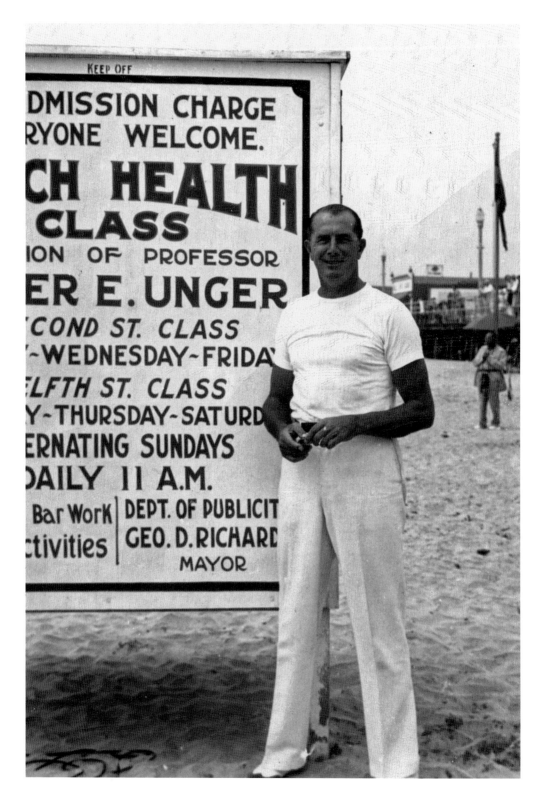

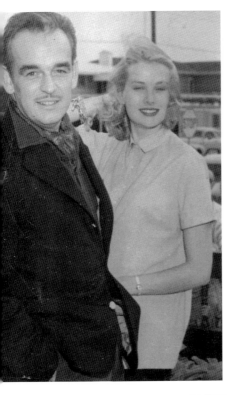

Kelly Family

The John B. Kelly Sr. family lived in Philadelphia, but had a summer home at 2536 Wesley Avenue in Ocean City. Kelly Sr. won gold medals in the 1920 and 1924 Olympic Games for doubles sculls rowing and, in 1920, also for singles sculls rowing. He was a strong supporter of the Ocean City Beach Patrol and a close friend of lifeguard captain Jack Jernee. Kelly was chairman of the US Committee on Physical Fitness in 1943. John B. Kelly Jr., known as Jack, was a member of the Ocean City Beach Patrol from 1942 to 1944. He was a champion rower for the lifeguards. He competed in the 1948, 1952, 1956, and 1960 Olympic Games, winning a bronze medal for singles sculls rowing in 1956. Grace Kelly was in her first movie, *Fourteen Hours*, in 1951, and went on to star in many more. She won an Academy Award for Best Actress for *Country Girl* in 1954. In 1956, she left films to marry Prince Rainier of Monaco. Princess Grace and her husband often brought their children to visit her parents in Ocean City. In the photograph, opposite page, John B. Kelly Sr. stands on the beach in Ocean City. Left photograph, Princess Grace and Prince Rainier pose in front of the Kelly home on September 12, 1956. Bottom photograph, James A. Rhodes, president of the Amateur Athletic Union, presents John B. Kelly Jr. with the 1947 James E. Sullivan Award as his proud father looks on.

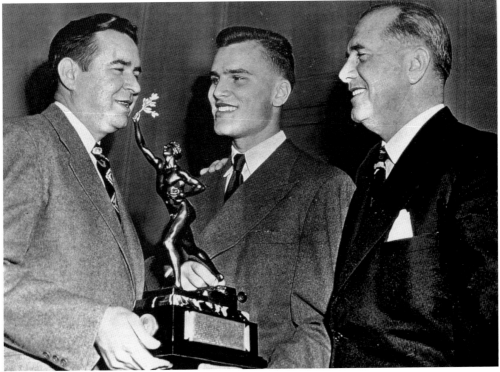

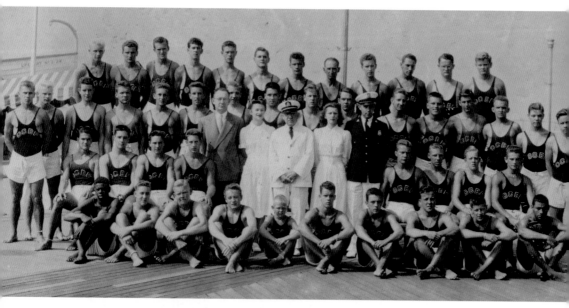

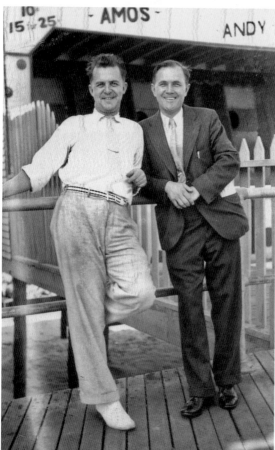

Willits P. Haines, MD

The great fire of 1927 destroyed the building at Ninth Street and Wesley Avenue where Dr. Haines had practiced medicine since 1910, but he rebuilt the office and continued to practice there. Beginning in 1918 and continuing for many years, he was a beach surgeon for the Ocean City Beach Patrol, on call for medical emergencies occurring on the beach. In this 1944 photograph of the beach patrol, he stands in the center in the white suit.

Alfred Senior Sr.

For many years, first on the boardwalk and then at 838 Asbury Avenue, Alfred Senior Sr. operated Senior Studio. A fine photographer, he photographed the events, buildings, and people of Ocean City for many years. After his death in 1972, his daughter and her husband, Doris and Robert Marts, took over the business. In this photograph taken on the Ocean City boardwalk, Senior stands on the left with an unidentified man.

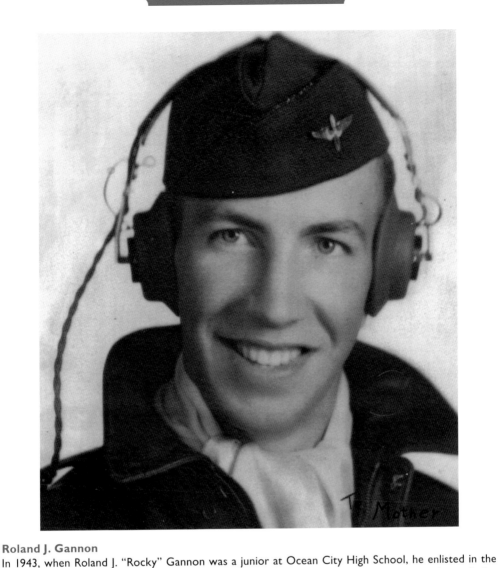

Roland J. Gannon

In 1943, when Roland J. "Rocky" Gannon was a junior at Ocean City High School, he enlisted in the Army Air Corps. He spent 37 years on active duty, flying 6,000 hours in 34 different airplanes during three wars, and received 50 military awards and decorations. In 1994, on what would have been the 50th anniversary of his graduation, Ocean City High School bestowed on Rocky his high school diploma. Gannon credits the Boy Scouts with helping to put him on the path to success. His father had died when he was nine years old, it was during the Great Depression, and the family had little money. Their home was still using kerosene lamps, because his mother could not pay to have electricity installed. Gannon told J. Prescott Cadman, scoutmaster of the local Boy Scout troop, that he could not afford to join. Cadman, an undertaker, told Gannon he could shovel snow, wash hearses, and do odd jobs around the funeral home; 15 cents would be held back to pay off his dues, the rest Gannon could take home. The money he gave to his mother she used to have electricity installed in their home. Said Gannon, "I never forgot my scoutmaster's kindness and lessons. He taught me how to work, save, keep books, and pay for my own debt." Gannon reached the rank of Eagle Scout, as have several of his grandchildren. He has served on the executive board and been president of his area Boy Scout Council. He has been recognized nationally for his work with the Boy Scouts of America. (Courtesy of Roland and Alberta Gannon.)

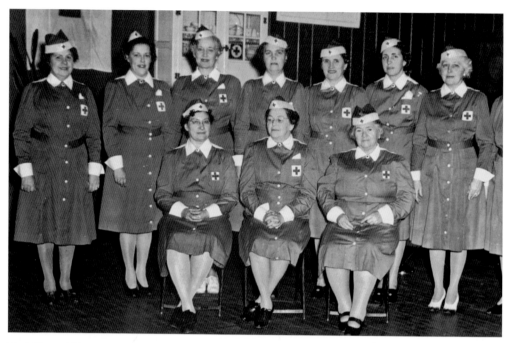

Red Cross Women

These women, working with the Red Cross during World War II, did whatever was necessary to help in the war effort. They ran a canteen and first aid station and helped patrol the beaches. Sitting, from left to right, are Florence Jeffries, Bertha Cole, and Julia Scull. Some of the other women in the group are: Virginia Crane, Rachel Schermerhorn, Marian Shafto, Norma Becotte, and Livinia Senior. (Courtesy of OCHM.)

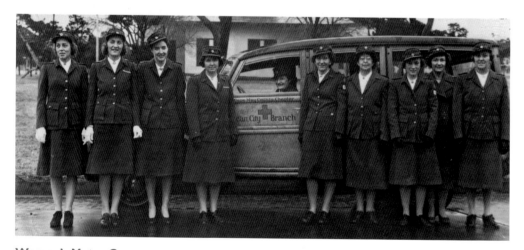

Women's Motor Corps

During World War II, these women served in the Ocean City branch of the American Red Cross motor corps. From left to right are Mrs. Robert Harbaugh, Mrs. John B. Townsend, Mrs. A.W. Oehlschlager, Mrs. Wilson Y. Christian, Mrs. Howard MacPherson (in the station wagon), Mrs. William Townsend, Mrs. Henry B. Cooper Jr., Mrs. C. Joseph Moyer, Mrs. Edna Townsend, and Mrs. Ewing Corson. (Courtesy of OCHM.)

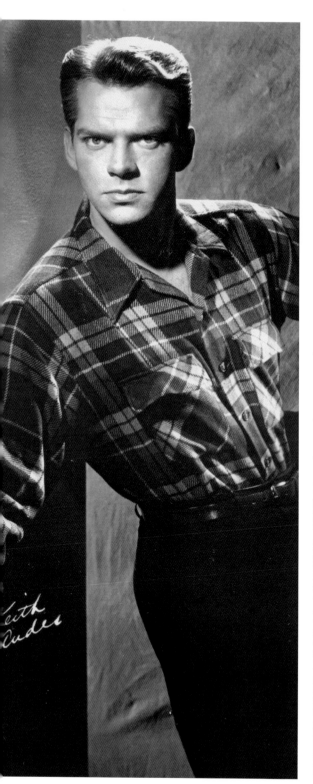

Keith Andes

Born John Charles Andes in Ocean City on July 12, 1920, movie producer David O. Selznick gave him the name Keith Andes in 1946. He was in the motion picture *The Farmer's Daughter* with Loretta Young, and played the male lead in the *Chocolate Soldier* on Broadway. In October 1950 Andes went to Hollywood, under contract to RKO, where he starred in the film *Clash by Night* with Marilyn Monroe.

South End Baseball Team

In August 1946, the South End Baseball Team, sponsored by Ollie Weiser, won their league championship. In this photograph are, from left to right (first row) Freddie Pinto, Jimmy Pinto, and Bill McGonigle; (middle row) Danny O'Sullivan, sponsor Ollie Weiser, and Jake Hamson; (top row) Pete Peiffer, Jack Miller, Harry Miller, Frazier Munsell, Bob Mason, and Al Kleeman. (Courtesy of Edna Streaker May.)

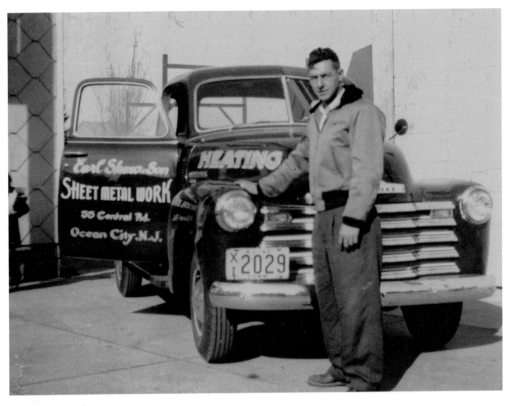

Earl L. Shaw Jr.
Shaw began working in the sheet metal and roofing business with his father, Earl L. Shaw Sr., in the early 1940s. His grandfather, Charles H. Shaw, began the business in 1923. With Shaw Jr. in the military, the business was closed during World War II but reopened after the war. Today, Thomas Shaw, the fourth generation, owns and operates the Shaw Roofing Company. (Courtesy of Joan Shaw.)

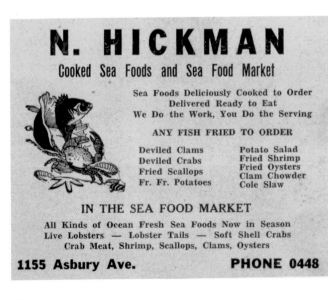

Nicholas Hickman
In 1895, Hickman opened Hickman's Seafood at 1155 Asbury Avenue, one of the city's first fish markets. Each summer he hired boys to deliver orders to households on their bicycles. A horse and wagon were used to make deliveries to hotels and boardinghouses. In the late 1920s, he realized that customers wanted their fish cooked as well as cleaned, so he installed a stove and hired a cook. This is a 1948 advertisement for Hickman's.

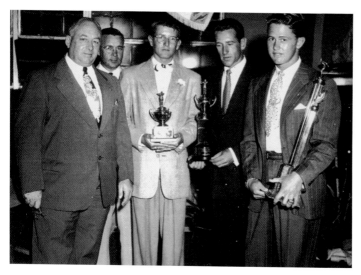

Edward B. Bowker
Elected as a city commissioner in 1939, Bowker was installed as mayor on May 10, 1949. He continued in office until 1959. He is shown presenting the Ocean City Beach Patrol 1949 swim trophies. From left to right are Bowker, Ocean City Beach Patrol captain Thomas Williams, Barney Hungerford, Joseph Sweeney, and Paul Geithner.

Augustus Shaw Goetz
The salutatorian of the Ocean City High School class of 1921, Goetz practiced law in the city for many years. He rowed pair-oared shell with coxswain in the 1928 Olympic Games in Amsterdam, Holland. In 1947, he was elected city commissioner, in charge of public safety. In this 1950 photograph of the Ocean City Police Department, Goetz is standing front row, center, with, on his left, Captain William Smith, and on his right, Chief Robert Lackey.

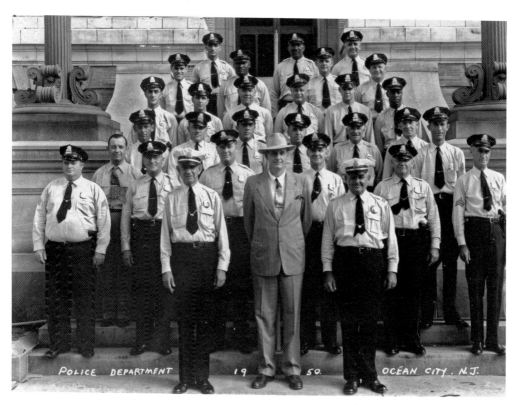

Gay Talese

Born and raised in Ocean City, author Gay Talese wrote a column for the *Ocean City Sentinel-Ledger* while still in high school. He graduated with the class of 1949. He attended the University of Alabama, served in the US Army, and joined the reporting staff of the *New York Times* in 1955. He is the author of several books including *Thy Neighbor's Wife, Honor Thy Father, The Kingdom and the Power,* and *Unto Thy Sons.*

Robert L. Smith

Joining the fire department on August 1, 1922, Smith was appointed chief on April 1, 1949. When Smith first joined the department, most of the men were volunteers. He was appointed captain in 1924, assistant chief in 1928, and deputy chief in 1938. In 1930, the department became fully paid. (Courtesy of OCHM.)

Nania Family

Anthony Philip Nania was born in Ocean City in 1918. He married Doris Lloyd, and they raised their three children, Sally, Donna, and Philip, in an apartment at 937 Asbury Avenue. All of the children attended Central Avenue School. Sally works for the City of Ocean City on special events. Donna has achieved much success with her outstanding needlework; she has operated Scrim Discovery Needle Work at 924 Haven Avenue for 35 years. Her granddaughter, Alexandra Russo, graduated from Ocean City High School in 2010, the fourth generation of the family to do so. After serving in Vietnam, Philip took over the family landscaping business; he now owns Nania and Sons Concrete. The top photograph is of Anthony Philip Nania. In the bottom photograph are, from left to right, Doris Lloyd Nania, Donna Nania Wilson, Sally Nania Huff, and Philip Nania. (Both photographs are courtesy of Sally Nania Huff.)

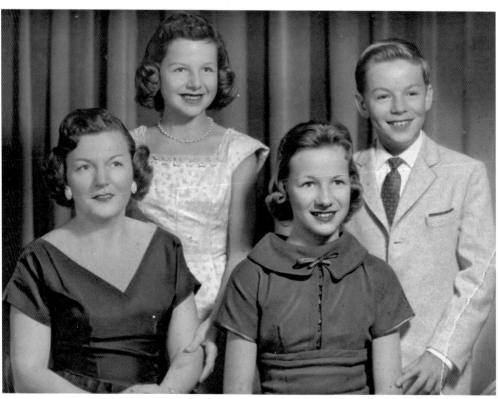

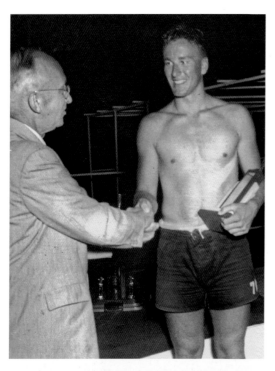

Oves Family

Owner of Oves Restaurant on the Boardwalk at Fourth Street, Thomas Oves was a rookie member of the Ocean City Beach Patrol in 1951 when he won the singles rowing championship, the first of many. Oves won many doubles rowing races as well as many more singles races, and was inducted into the Ocean City Beach Patrol's Hall of Fame in 1975. His father Reuben was an Ocean City lifeguard from 1910 to 1917. His son Christopher began his lifeguard career in 1984. Christopher was also a rowing champion, and was inducted into the patrol's Hall of Fame, along with his cousin, Joseph Sheffer, in 2005. Thomas taught at Wildwood High School for many years; Christopher teaches at Atlantic City High School. In the top photograph, taken in 1951, city commissioner Lawrence Lunny is presenting Thomas Oves with his trophy. In the bottom photograph, Sheffer is on the left with Christopher Oves as they steer their boat to another victory in 1991.

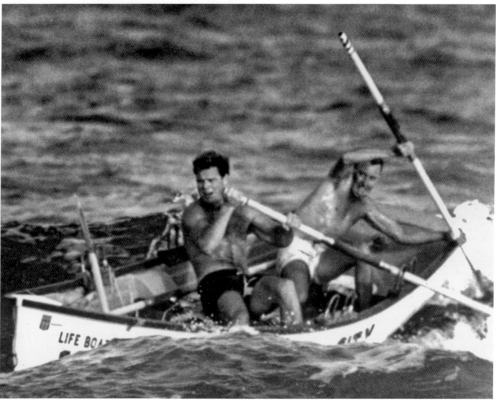

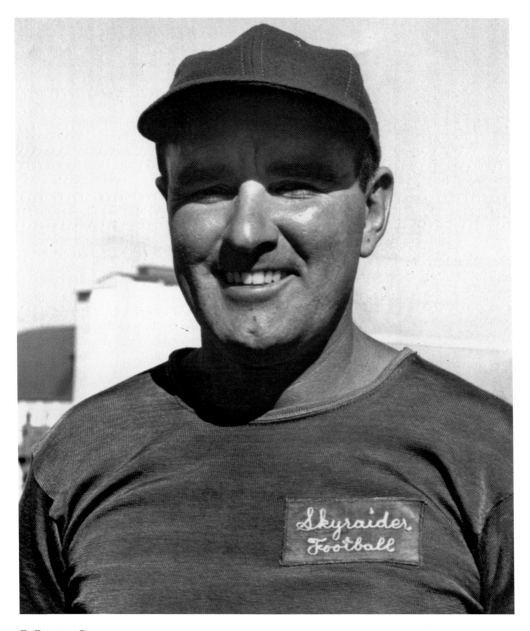

E. Fenton Carey

After 29 years as physical education teacher and coach, Carey retired from Ocean City High School on January 30, 1976. A 1932 Ocean City High School graduate, quarterback of the undefeated 1931 football team, captain of the track team, school record holder in the 880 and mile, and high school swim champion himself, he coached championship teams in football, swimming, basketball, baseball, and track and field. During his high school and college years, he was also a champion rower with the Ocean City Beach Patrol and was inducted into their Hall of Fame in 1984. He was on the National Lifeguard Championship Team in 1935 and was an Atlantic Coast Rowing Champion in 1940. Carey received the New Jersey Coaches Association Award for "Outstanding Contributions to the Coaching Profession" in 1966, and in 1979 he was elected to the South Jersey Coaches Hall of Fame.

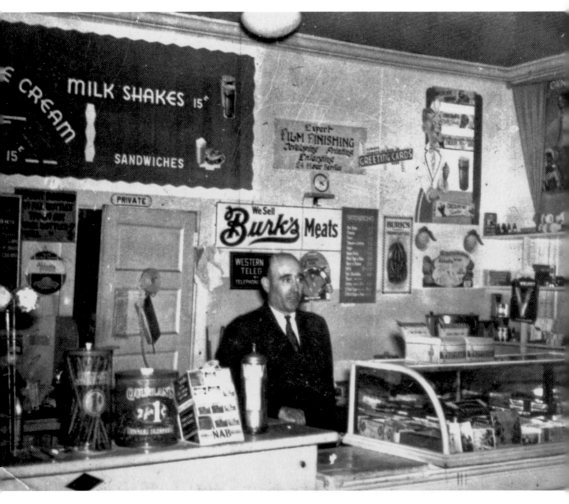

Anthony and Maria Pinto
Anthony and Maria Pinto made their home at 5816 Central Avenue, but spent their time on 59th Street. Starting in 1931, the Pintos operated a fishing pier at 59th Street and the bay and a store at 59th Street and the beach. The Pintos were popular figures, known to the thousands of summer visitors and locals who fished at the pier or stopped at their store for a milkshake or sandwich. (Courtesy of Edna Streaker May.)

CHAPTER THREE

All Roads Lead to Ocean City

Businesses continued to prosper. The Atlantic City Expressway, which opened in 1964, coupled with the New Jersey Turnpike and the Garden State Parkway, made it much easier to come to the resort for a short stay or even for the day. This led to the decline of the large hotels and the increase of motels, modern duplexes, and condominiums. Restaurants and retail stores flourished with the influx of visitors. Athletics continued to play an important role here. The high school basketball team, coached by Fred "Dixie" Howell, won state championships in 1955 and 1964 and Coach Fenton Carey's football team won multiple championships as well. The Ocean City Youth Athletic Association was formed in 1956. Local woman Vernice Turner won the United Golfers Association Women's Championship in both 1958 and 1961. In 1971, the beach patrol, under Captain George Lafferty, won its 11th straight South Jersey titles in both ocean and pool tournaments. Two new schools were built and the educational program continued to be among the best in the state. The art and music community thrived with the opening of the Ocean City Arts Center, the Boardwalk Art Show, and the Ocean City Pops orchestra, which brought many young performers to the Music Pier concerts. The first woman, Jeanne Clunn, was elected to city council.

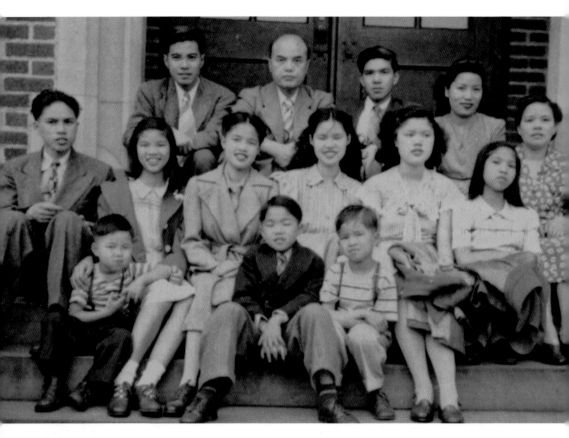

Lee Family

Sing Wah Lee and his wife opened their laundry in the 900 block of Asbury Avenue in December 1912, and over the next 39 years it became one of Ocean City's most successful businesses. After moving here and opening their laundry, the Lees raised a remarkable family. The oldest Lee children were born in Canton, China, and brought here when very young. All of the children graduated from Ocean City High School with honors. All of them went to college or nursing school, except for Thomas, who had a successful career as a jockey. Although the children settled in different parts of the country, they stayed in close touch with each other and frequently returned home to Ocean City.

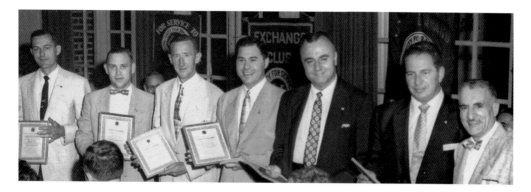

Ocean City Exchange Club Presidents

In 1956, past presidents of the Ocean City Exchange Club were honored on the club's ninth anniversary. From left to right are Harry S. Adams Jr., Charles H. Ash, Robert L. Sampson, Dr. Roger G. LaRosa, Charles Munich, Robert A. Kershaw, and Anthony Imbesi. The Ocean City Exchange Club, chartered June 4, 1947, has as its national project the prevention of child abuse. The organization sponsors many activities including the annual Halloween parade and the Miss Ocean City Pageant.

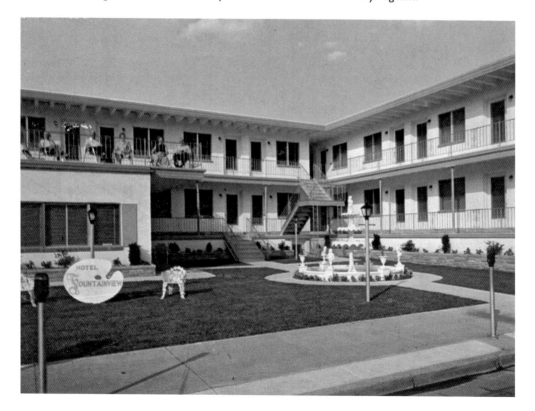

Francis and Ethel West

When Francis and Ethel West opened the Fountainview at 811 Atlantic Avenue in 1956, city ordinance did not allow motels. Although built like motels in other cities, with all outside rooms and private entrances, the city required it to be called a hotel. The Wests advertised it as "Ocean City's Newest and Finest MOdern hoTEL."

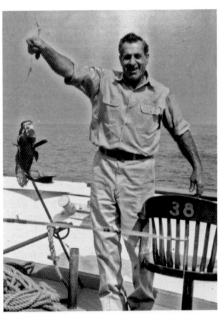

Chris Montagna

Chris' Seafood Restaurant and Fish Market, next to Hogate's Restaurant on the bay at Ninth Street, was owned by Chris Montagna. The fish were brought in daily by the market's boats, packed, and shipped wholesale to all parts of the country. The dining room could seat 250 people at a time and was open daily from noon to 9:00 p.m. Montagna was known for his fleet of converted PT boats, which thrilled passengers with their speed; he was usually at the helm of the fastest boat. His fleet also contained slower boats for sightseeing trips around the bay, and restaurant patrons never minded a delay in getting a table if they could have a ride on one of the boats while they waited. Montagna was married to Dr. Marcia V. Smith, Ocean City's first woman doctor, for over 50 years. (Both photographs courtesy of OCHM.)

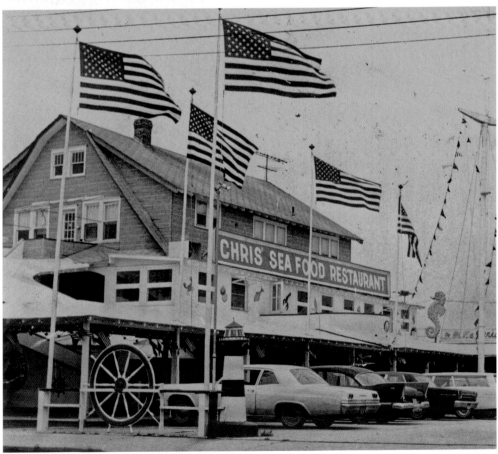

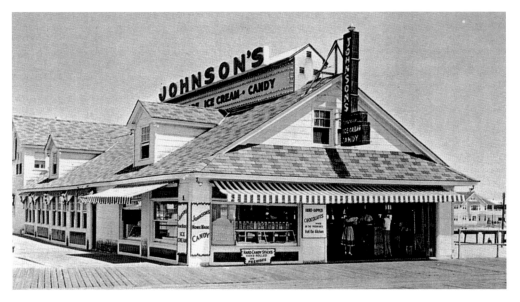

Ira S. and Emma Johnson
Johnson's Ice Cream and Candy Store was founded by Ira S. and Emma Johnson in 1930. They advertised "A Sourball in Every Cone," because they dropped a sourball candy in each cone before putting in the ice cream. By September 2, 1969, son Edward and his wife Elizabeth had taken over the business when an early morning fire burned the building to the ground, killing their 15-year-old son, James, who was asleep in the apartment above. The rest of the family escaped injury.

Eugene E. Halleran
Ocean City High School teacher, baseball coach, and bandleader Eugene E. Halleran was also an author who wrote several popular western adventure stories. His books included *Rustler's Canyon*, *Gringo Gun*, *Shadow of the Big Horn*, and *Double Cross Trail*. He won the Spur Award, given to exceptional writers of stories about the American West.

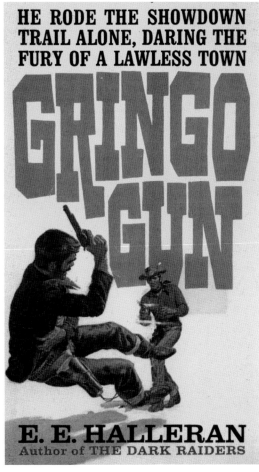

HE RODE THE SHOWDOWN TRAIL ALONE, DARING THE FURY OF A LAWLESS TOWN

GRINGO GUN

E. E. HALLERAN
Author of THE DARK RAIDERS

Vernice Harris Turner
Avid golfers, Turner and her husband David were charter members of the Apex Golf and Country Club, the first African American–owned golf course in New Jersey. She won the United Golfers Association Championship in 1958 and 1961 and was inducted into the African American Golfers Hall of Fame on May 29, 2011. Turner has been recognized for her involvement and excellence in the sport of golf in *The Road to Glory* by Arthur Ashe, *The African Woman Golfer—Her Legacy*, and *Heroines of African American Golf*, the latter two by Dr. M. Mikell Johnson. The Turner children, Madelyn, Janet, and David, also were excellent golfers. Madelyn won several girls' junior division tournaments. Son David was on the Ocean City High School golf team. He was also a member of the Ocean City Beach Patrol. (Courtesy of David Turner.)

Harry Vanderslice Sr.

Coach, umpire, and president of the Ocean City Youth Athletic Association for almost 50 years, Vanderslice was a "second father" to many local youth. Although he had eight children of his own, he was never too busy to coach or counsel a child who needed his help. He had a reputation as a mentor of young athletes. The OCYAA field at 36th Street was named in his honor. In the photograph, Vanderslice participates in the annual Halloween parade.

Harold Lee

Lee began a long writing career with the *Ocean City Sentinel-Ledger* while a senior at Ocean City High School. He became assistant editor in 1942 and editor in 1953. He continued as editor until he left the newspaper to work with his wife, Dorothy, in her store, Warren's Gift Shop, at 834 Asbury Avenue. In 1965, he wrote *A History of Ocean City* and in 1979, *Ocean City Memories*.

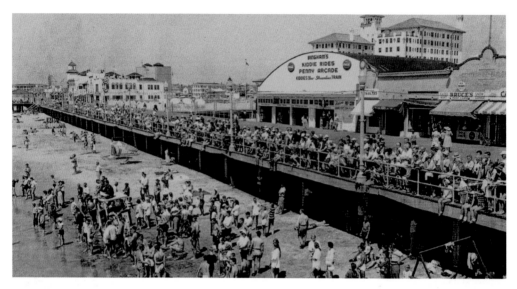

David L. Simpson

In 1959, David L. Simpson and Fred Tarves bought Bingham's Kiddie Rides on the Boardwalk between 10th and 11th Streets, did some remodeling, and reopened the summer of 1960 as Playland Amusement Park. In 1971, Simpson bought out Tarves and his son Scott Simpson began working with him. Playland has been enlarged over the years and now includes a miniature golf course. It is now called Playland's Castaway Cove.

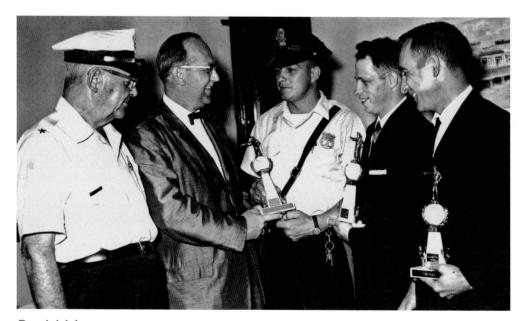

Dominick Longo

Dominick Longo joined the police department in 1954, was made chief of police in 1974, and in 1991, after a reorganization of city departments, director of public safety. In this 1960 photograph of the pistol championship winners are, from left to right, police chief William H. Smith, commissioner D. Allen Stretch, and officers William Gannon, John Vanderpool, and Dominick Longo.

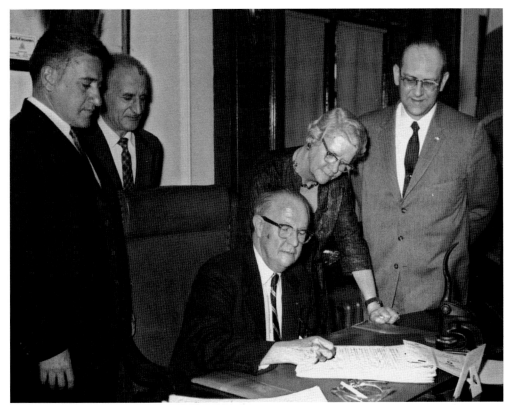

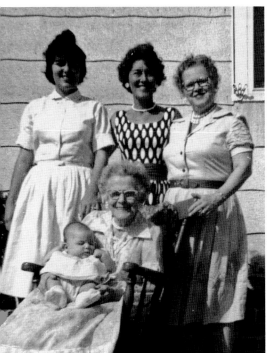

Nathaniel Champion Smith

Nathaniel Champion Smith was chairman of the Cape May County Executive Committee from 1942 to 1943. He served as secretary to the State Assembly in 1942 and was a member of the assembly from 1943 to 1954. On May 12, 1959, he was elected as a city commissioner along with D. Allen Stretch and B. Thomas Waldman and chosen mayor. He served until 1963. Mayor Smith is shown signing the bond to fund the municipal sewage plant in 1961. (Courtesy of OCHM.)

Bakley/Provenson Family

Debra Anne Bakley and her twin sisters, Dawn Marie and Denise Marie Bakley, are fifth-generation Ocean City women. In this 1961 photograph, Debra is sitting on the lap of her great-great-grandmother, Lillian Glasby. Standing are, from left to right, Debbie's mother, Joyce Provenson Bakley, Debbie's grandmother, Elsie Rotan Provenson, and Debbie's great grandmother, Elsie Glasby Rotan. Debbie, her sisters, mother, and grandmother all graduated from Ocean City High School. (Courtesy of Joyce Bakley-Trofa.)

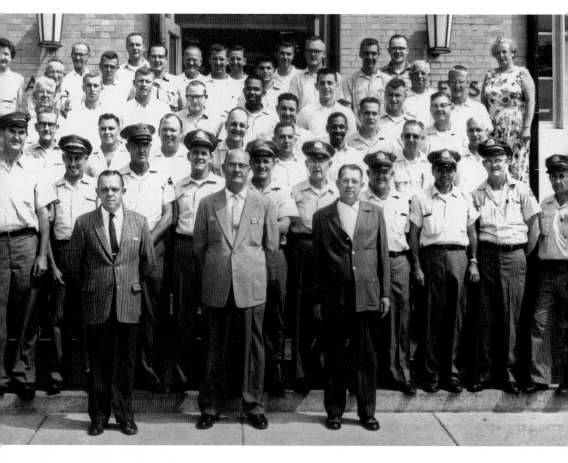

Richard and Marizita Grimes

In 1926, when Richard Grimes was seven years old, he went to live with his grandmother, Emma Davis, in Ocean City. He has been here ever since. Drafted into the Army at the beginning of World War II, Grimes served for five years. When he returned home, he went to work for the Ocean City Post Office, the first African American employed there. He met his wife, Marizita Miles Grimes, when she came to Ocean City to work one summer. She, too, never left. She had received her college degree from the University of Maryland Eastern Shore and got a job teaching home economics at Ocean City High School, the first African American to teach there. The couple had two daughters, Clarissa and Rita. Over the years, Richard Grimes has been involved in numerous charitable and athletic organizations, including the Ocean City Ecumenical Council, where he helped establish the Food Cupboard and the Clothes Closet, the Housing Authority, the Boy Scouts, and the recreation department. An avid tennis player, he worked to get lights installed for a night tennis program. He helped organize the Ocean City Youth Athletic Association in 1956, the Little League baseball program, Hawks youth football program, and a youth basketball program. In 1997, the Ocean City Exchange Club honored Grimes by placing him in their Book of Golden Deeds, an award given "in recognition of sacrifices and unselfish service to the community." In 2007, the Ocean City Chamber of Commerce recognized him for his many contributions to the community by naming him Citizen of the Year, and on June 7, 2008, the playing field at Sixth Street and Haven Avenue was dedicated in his name. In this photograph of the Ocean City Post Office Department, Grimes stands in the third row, sixth from left. (Courtesy of Edna Streaker May.) Next page, Marizita Miles Grimes (Courtesy of OCHM), and Richard Grimes (Courtesy of Donald B. Kravitz.)

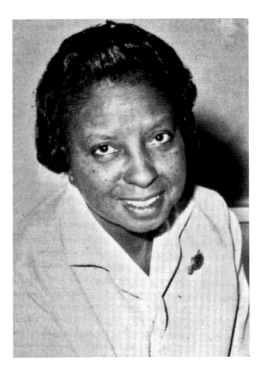

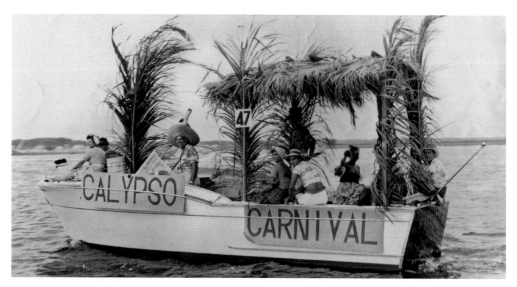

Derr Family
Chester Derr's family began decorating their boats for Ocean City's annual Night in Venice boat parade in 1954. With lights and music, the boats always won a prize. In 1956, *Let's Go to Paris* featured a lighted Eiffel Tower and Parisian music. This 1961 entry, *Calypso Carnival,* took first prize in its division. (Courtesy of Denny and Chet Derr.)

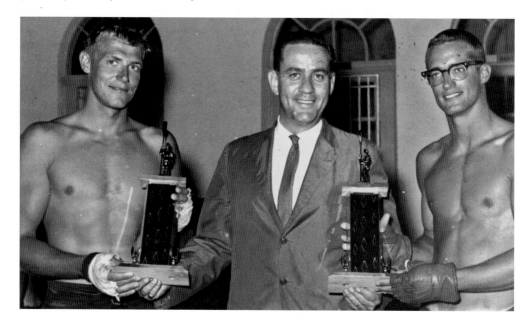

B. Thomas Waldman
After the May 14, 1963, city commission election, Waldman was chosen mayor and served until 1967. In this 1963 photograph, he is congratulating Ocean City Beach Patrol South Jersey rowing champions Hans Giesecke, left, and George Thieler. After the May 13, 1971, city commission election, he was again chosen mayor and served until 1978. He made one of his most important decisions in 1971 when he appointed Mark Soifer to the newly created position of Director of Public Relations.

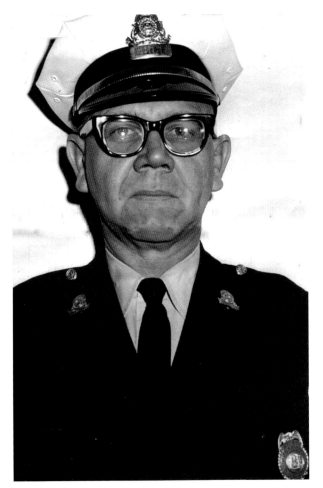

Benjamin L. Dungan

A 1940 graduate of Ocean City High School, Dungan spent his summers as a member of the beach patrol. In 1942 he enlisted in the service. After his honorable discharge in 1946, he returned home to join the Ocean City Police Department. Dungan moved up through the ranks, to sergeant in 1948, detective sergeant in 1954, and captain in 1962. In 1965, he was appointed chief, the position he held until his retirement in 1974. (Courtesy of Bonnie and Pete Ault.)

Fred E. "Dixie" Howell

In this 1964 photograph of the Ocean City High School state championship basketball team, Coach Howell sits in the center of the first row. Howell came to the school in 1952 as a teacher-coach, and immediately started building the team. Beginning with the 1954-1955 season, they won eight straight Cape-Atlantic League championships. In 1955, the team won the state championship. In 1963-1964, Howell was named South Jersey Coach of the Year. The 1965 class dedicated their yearbook to him.

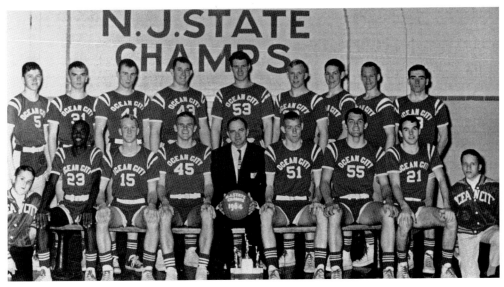

Nathan Davis

An honor roll student at Ocean City High School, class of 1955, Davis was also an outstanding athlete. He was a member of the 1955 state championship basketball team coached by Fred "Dixie" Howell. Davis is a graduate of Rutgers University and Howard University School of Law. He was the first African American to practice law in Cape May County, the first to be appointed to the Shore Memorial Hospital Board of Trustees, and the first to be elected president of the Egg Harbor, New Jersey, Board of Education. He is president of the administrative board of Macedonia United Methodist Church of Ocean City and president of the Ocean City Ecumenical Council. In this photograph of the 1955 team, Davis is seated on the right. (Courtesy of Emma and Nathan Davis.)

Charles B. Pierce

Pierce came to the Ocean City public school system as superintendent in 1950. He continued in that position until his retirement in 1969. He was instrumental in the building program, and during his tenure two new elementary schools were built, one, now the primary school, on West Avenue between Fifth and Sixth Streets, and the other, now the intermediate school, on Bay Avenue between 18th and 19th Streets. Two additions were also built onto the high school. The photograph is of the school on West Avenue, built in 1965.

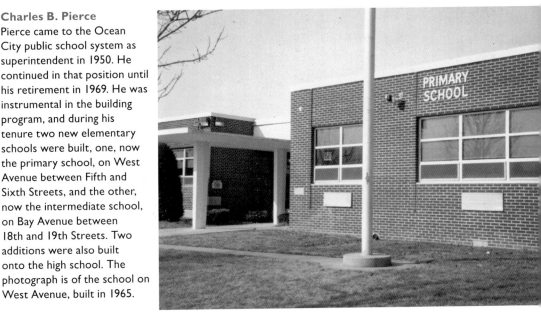

Ferdinand Taccarino

Joining the Ocean City Fire Department in 1931, Taccarino continued to serve until 1978, the longest tenure of any city fireman. He was named chief in 1962. In this photograph of the 1964 fire department, Fire Chief Taccarino stands second from left in the front row with City Commissioner of Public Safety D. Allen Stretch, in the center.

Louis Davis

Graduating from Ocean City High School in 1956, Davis was a star pole vaulter on the track team and played clarinet in the band. After high school he joined the army, where he served for two years with the 35th Artillery, stationed in Wertheim, Germany. He was honorably discharged with the rank of corporal. In 1965, Davis joined the fire department, becoming the first African American firefighter in Ocean City's history. He was appointed captain on September 1, 1991. Davis served 38 years with the fire department before retiring in 2003. He won the boardwalk Easter Parade's Best Dressed Male competition so many times that the parade committee made him a judge! In the photograph at right, Louis Davis is on the left with his brothers, Carlton, center, and Nathan. (Top photograph, courtesy of Jamie and Louis Davis.) (Right photograph, courtesy of Emma and Nathan Davis.)

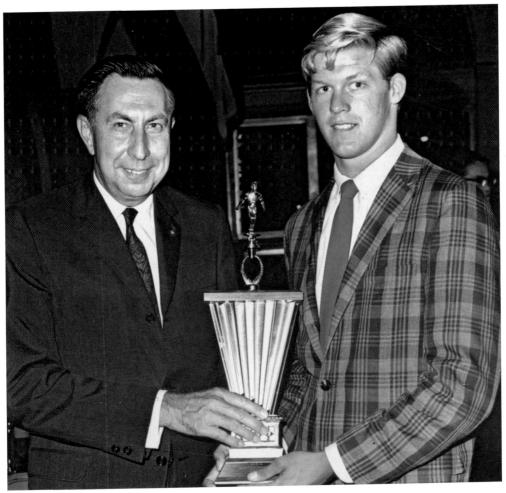

Robert L. Sharp
A former city tax assessor, Sharp ran for city commission in 1967 and won, along with David L. Simpson and R. Robinson Chance Jr. Sharp was chosen mayor and served until 1971. In this 1967 photograph, Sharp presents lifeguard Bruce Wigo with the South Jersey Lifeguard Swim Meet trophy.

William C. Lauer
The Ocean City High School class of 1967 dedicated their yearbook to Lauer for his "dedication to his students." "Doc" Lauer, as he was known, taught business subjects, but he also taught business manners, appearance, and speech to his classes. He was advisor to the senior class and the business club. After his retirement from the high school, he continued to work with the senior classes on their yearbooks and graduation.

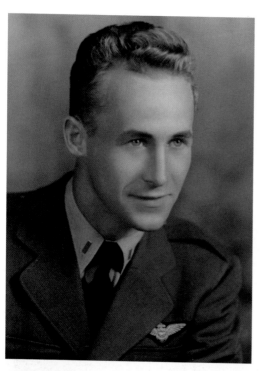

Robert French

A graduate of Ocean City High School, French joined his father's real estate firm located at 1 Atlantic Avenue in 1946 when he returned after three years as a pilot for the Navy. His wife, Marie, worked with him in the office. After a ten-story apartment building was constructed adjacent to the boardwalk, French joined a group of realtors in successfully petitioning the planning board to prevent any more high-rise apartments or hotels from being built in the city. He was also instrumental in getting New Jersey Green Acres funds to buy the Wheaton Estate, a large property on the open bay at 520 Bay Avenue. This property, now called the Bayside Center, is leased to the city from Cape May County for a nominal fee. It houses a lifeguard museum, an environmental center, and conference rooms, and provides open space for residents and visitors. (Both photographs courtesy of Robert French.)

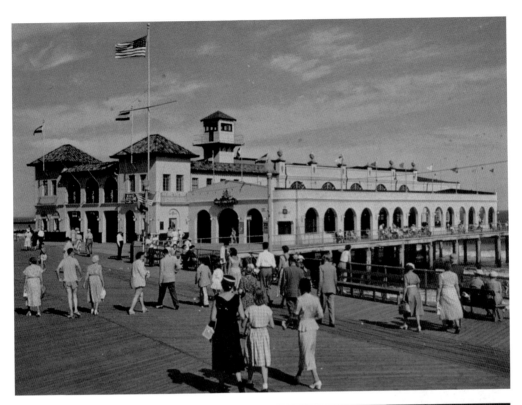

Clarence Fuhrman

Fuhrman was the conductor of the Ocean City Music Pier Orchestra from 1950 to 1975. For many of those years, the orchestra played six nights a week for the ten-week summer season. Conductor Fuhrman never missed a concert. Offered free at the Music Pier on the Boardwalk at Moorlyn Terrace, Fuhrman's concerts had an informal air that made them popular with all age groups. The photograph shows the Music Pier in 1951.

Evelyn and Russell Hanscom

The Baby Parade has been a highlight of the summer for over 100 years, and for many of those years Evelyn and Russell Hanscom were a big part of it. Involved in the parade since the 1930s, the Hanscoms became its unpaid directors in 1946 and continued in that capacity until they retired in 1979. They handed the parade over to Priscilla Parker and Doris and Dutch Dalhausen.

Howard S. Stainton

In 1913, Stainton bought a small dry goods store at 810 Asbury Avenue from Ethel Morris Corson, and renamed it the "Men's Shop." By the early 1960s he had enlarged his store several times and changed the name to Stainton's Department Store, the first department store in Cape May County. Stainton hired as many local people as possible, which generated great loyalty in his employees and customers. He was one of the earliest developers and built many of the single-family homes in the Gardens and Riviera sections of the city. Stainton was known for his philanthropy: he donated a large pipe organ and a chapel to the First United Methodist Church; he made donations of property, contributing the ground for the Wesley Manor Nursing Home and for the senior center; and when oil prices were high, his Seashore Oil Company provided heating oil for the Cape May County Rescue Squad and the Marmora Volunteer Fire Company at no charge. Stainton was known for his generosity: he had a store policy allowing local customers to "run a tab." He never charged interest and had no minimum payments due. People paid when they could. More than 9,000 accounts were handled that way, allowing residents who relied on seasonal business a place to shop when money was short. Stainton was honored many times: in 1976 the Ocean City Exchange Club recognized him for his good deeds with their Book of Golden Deeds Award, and he received many other awards and accolades over the years. After his death, at 93, his store was run by a board of directors comprised of close business associates and six store employees. His will stipulated that store profits should be split between Shore Memorial Hospital and the Pennington School. In the 1980s, the store was closed and the property sold. It now contains small shops on the first level and meeting rooms on the second. The photographs show Stainton's Department Store in 1951 and Stainton, standing with hands on hips, inside his store. (Courtesy of Art Ford.)

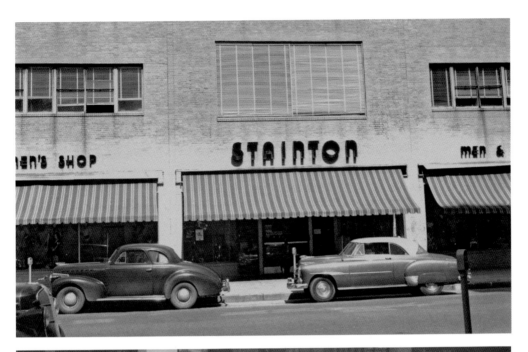

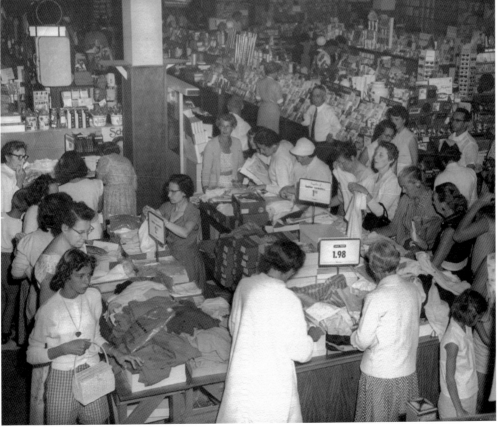

Michael M. Subotich
Subotich was superintendent of the Ocean City public schools from 1969 to 1987. He began teaching at the high school in 1953, was appointed assistant principal in 1957, and principal in 1964. He was an active member of the Ocean City Exchange Club and a past president of the organization. In 1959, the *Ocean City Sentinel-Ledger* named him Man of the Year.

Thomas Perkins

A regular soloist with the Ocean City Orchestra for over 40 years, Perkins came to Ocean City in 1937 and stayed until his retirement in the mid-1980s. A baritone, he also sang with the Philadelphia Orchestra. He performed on Broadway and toured the country, appearing in many productions, but always returned to Ocean City for the summer season. (Courtesy of Edna Streaker May.)

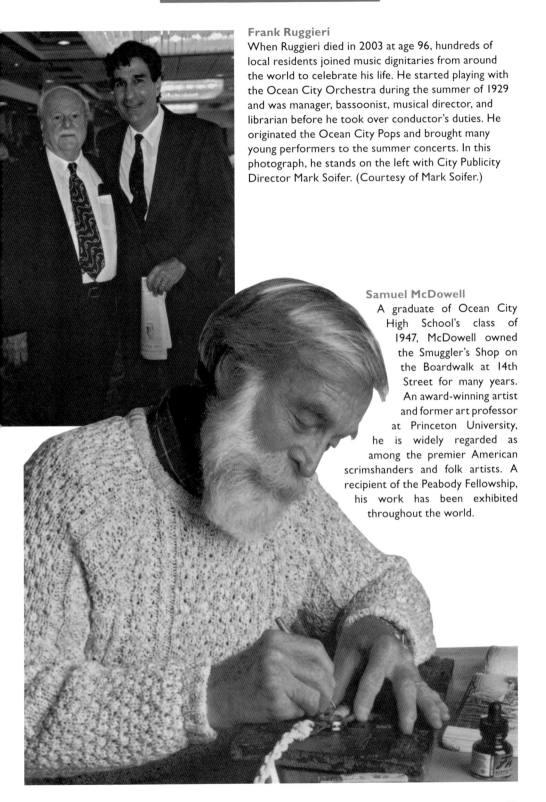

Frank Ruggieri

When Ruggieri died in 2003 at age 96, hundreds of local residents joined music dignitaries from around the world to celebrate his life. He started playing with the Ocean City Orchestra during the summer of 1929 and was manager, bassoonist, musical director, and librarian before he took over conductor's duties. He originated the Ocean City Pops and brought many young performers to the summer concerts. In this photograph, he stands on the left with City Publicity Director Mark Soifer. (Courtesy of Mark Soifer.)

Samuel McDowell

A graduate of Ocean City High School's class of 1947, McDowell owned the Smuggler's Shop on the Boardwalk at 14th Street for many years. An award-winning artist and former art professor at Princeton University, he is widely regarded as among the premier American scrimshanders and folk artists. A recipient of the Peabody Fellowship, his work has been exhibited throughout the world.

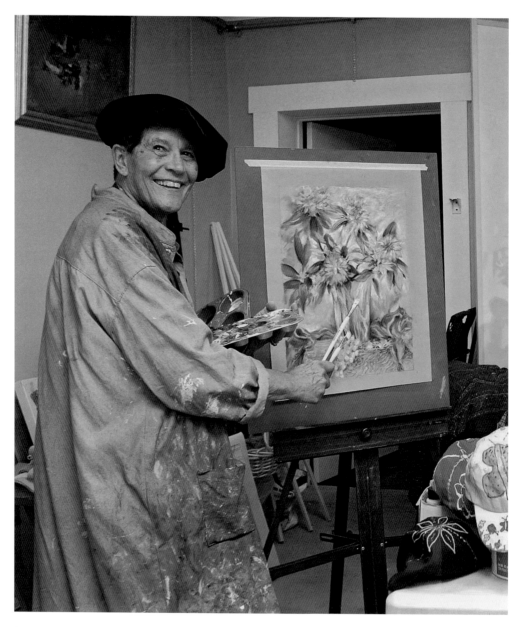

James Penland

Moving from Lakeland, Florida in 1954, Penland was immediately smitten with Ocean City, or as he called it, "Sleepy Hollow with an ocean view," and Ocean City was immediately smitten with him. An artist, Penland became a central figure in the arts in Ocean City. During the 1960s, he insisted that this shore town could sustain a year-round active arts community, and he founded the Ocean City Arts Center. He helped establish the Boardwalk Art Show and the Ocean City Flower Show, and opened the Connoisseur Shoppe and Penland Place, both retail stores on Asbury Avenue. Later, he started the Ocean City Fine Arts League and through this venue created an outreach program to assist disabled adults through art programs. As a young man, he had taught art to impoverished people in the Philippines and Malaysia. (Courtesy of Donald B. Kravitz.)

Robert Speca

Robert "Domino" Speca is an Ocean City lifeguard, physics teacher, and former ironman tri-athlete, but he got his nickname for setting up and knocking down dominoes. A swimming standout and astronomy major at the University of Pennsylvania, Speca took to toppling dominoes as a way to relax. Soon, he was entertaining his fraternity brothers and others, and everyone at the university started calling him "Domino." The moniker stuck. In 1974, he set the original Guinness Book of World Records record for domino toppling. Speca, who last held the record with 111,111, appeared on the *Tonight Show with Johnny Carson, That's Incredible,* the *Mike Douglas Show,* and the *Ellen DeGeneres Show,* and has set up dominoes on the Great Wall of China. He has written two books on dominoes, *The Great Falling Domino Book* and *Championship Domino Toppling.* (Courtesy of Robert Speca.)

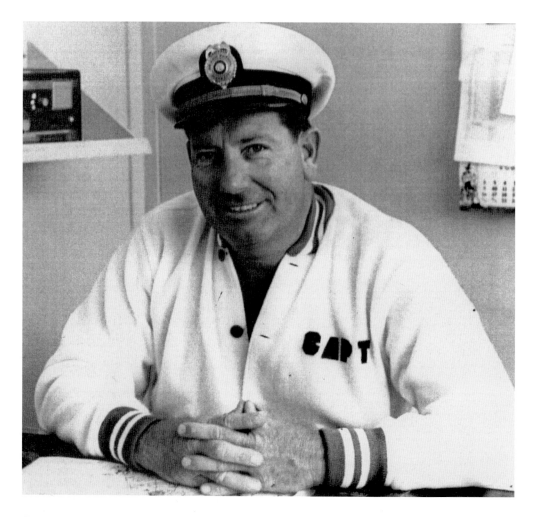

George T. Lafferty

Capt. George T. "Cap" Lafferty led the Ocean City Beach Patrol for 22 years, from 1962 to 1983. During those years, the patrol won the coveted South Jersey Lifeguard Championship a record 15 times, the Margate Memorial Championship 10 times, seven Dutch Hoffman Championships, and 15 South Jersey Pool Swimming Meets. Lafferty was born and raised in South Philadelphia and graduated from South Philadelphia High School, where he was a member of the varsity football and track teams. He was a member of the Ocean City Beach Patrol from 1936 to 1938. During World War II, he served on a naval destroyer in the South Pacific and continued at the Philadelphia Naval Shipyard until his retirement in 1961 with the rank of chief quartermaster. Lafferty used his naval training to spur on his lifeguards. Each morning they were to arrive at muster in clean uniforms, well groomed, and respectful; he was training them to be not only good lifeguards, but good men and women. Lafferty said that one of the things he most liked about his job was that "you made such good friends with young people." Lafferty's wife, Bettie, played an important role too. At the end of each summer, she would clean and mend the lifeguard jackets and make sure they would be ready for the next summer's use. More importantly, she was always there to lend an ear to a guard with a problem and to offer a hot meal when needed. In the top photograph, next page, authors Fred and Susan Miller flank Bettie and George Lafferty. In the bottom photograph, next page, Lafferty, left, stands with Bob Bennett, one of the Ocean City Beach Patrol's top swimmers in 1962.

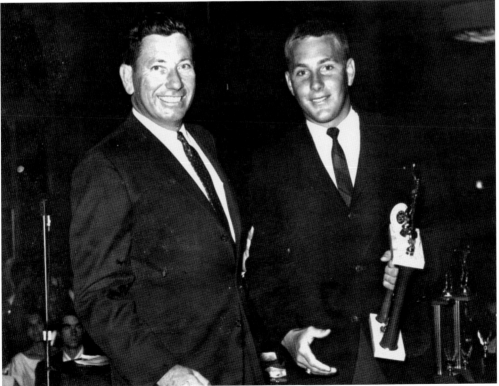

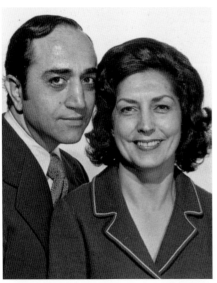

Angela and James Pulvino
In 1972, when Ocean City native Angela Pulvino was elected as Cape May County Clerk, she was the first woman elected to any county governmental position. She served as county clerk for 33 years, until her death in 2005. Her husband, James Pulvino, was an art teacher at Ocean City High School for many years. He was appointed assistant principal there in 1964.

Bernard W. Morris Jr.
Morris graduated from Ocean City High School, where he excelled in football. He served in the National Guard and in the US Army before receiving an honorable discharge in 1957. In 1959, he joined the Ocean City Police Department and served for 30 years before retiring in 1989.

Chester J. Wimberg
Wimberg was the first to be elected mayor when the city administration was returned to the mayor-council form of government in 1978. His term ran until 1982. He was the owner-operator of the Wimberg Funeral Home in Ocean City.

William E. Meis
When Meis ran for and won a council seat in 1978, he was already president of the Ocean City Hotel, Motel, and Restaurant Association. He worked to have the Sunday restrictions on business and recreation lifted. This 1978 photograph of the city council shows, seated from left to right, Jack M. Jones, council president William H. Woods, and Henry Knight; standing left to right are Nickolas Trofa Jr., Herbert J. Brownlee Jr., Meis, and Jeanne Clunn.

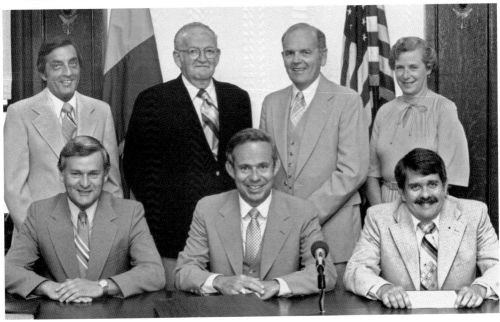

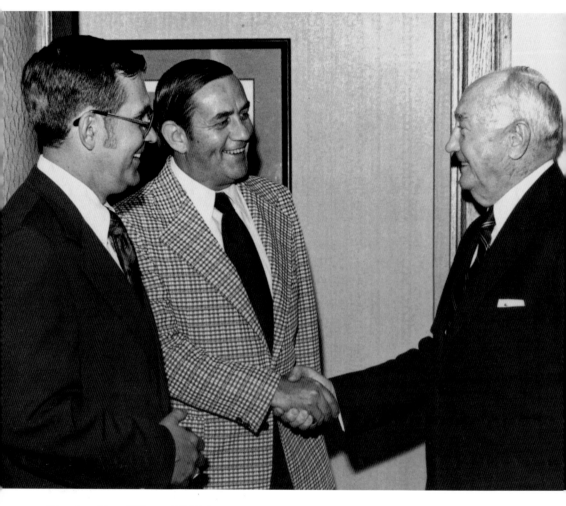

Flanders Hotel/Elwood F. Kirkman

In 1932, Kirkman purchased the elegant Flanders Hotel on the Boardwalk at 11th Street, a few years after the original owners lost it due to the stock market crash of 1929. The hotel, designed by local architect Vivian Smith and named for Flanders Field in Belgium, opened in 1923. It offered a full schedule of in-house activities including Saturday evening dance parties, Sunday evening music concerts, shuffleboard, and miniature golf. There was a large saltwater swimming pool, a diving pool, a children's pool, and a smaller private pool. Room charges included daily breakfast and dinner. Afternoon tea was served every day at 3:30 p.m. A dress code required that all men wear suits or jackets when they dined, and that no bathing suits or immodest dress be worn in the upper or lower lobbies. For forty years, the hotel lured well-to-do visitors from around the region, many staying for weeks at a time, but by the late 1970s the summer clientele could not sustain the hotel expenses and Kirkman began extensive renovations during the off-season, thinking they would help bring visitors back to the hotel. His reputation was severely tarnished around that time by a series of lawsuits accusing him of conflict of interest, defrauding shareholders in an investment company he controlled, and acquiring thousands of acres of New Jersey pinelands through the use of phony land titles. The hotel was closed in 1995. In 1996, it was sold to developer James Dwyer, who converted it to a condominium hotel. In the August 1975 photograph on this page, are, from left to right, Eugene Lindacher, mayor B. Thomas Waldman, and Kirkman. (Courtesy of Eugene Lindacher.)

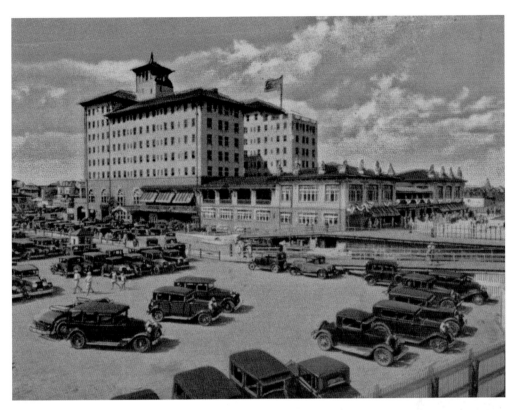

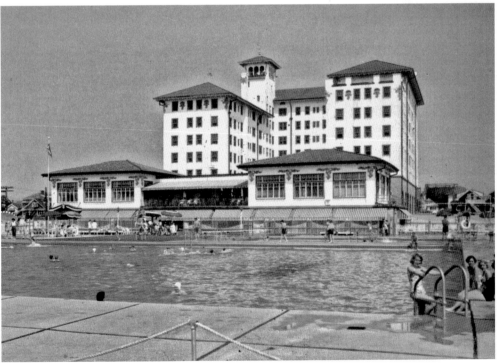

Jeanne Clunn
Clunn was the first woman elected to serve on city council. She was elected in 1978, the year Ocean City changed from a commission to a mayor-council form of government. She served four terms and was council president twice. Clunn was one of the first advocates for recycling in the city and succeeded in getting an ordinance passed requiring homeowners to recycle. She was also instrumental in creating the ordinance establishing Ocean City's Historic District. She was very involved in the preservation of the Music Pier and city hall. Clunn served on the Historic Preservation Commission, the Ocean City Housing Authority, the Coastal Conservation Commission, and the Clean Communities Advisory Board. She was an integral part of Ocean City's Beach Walk Program, which helps educate locals and visitors about marine life on the beach and dunes.

CHAPTER FOUR

A Summer Vacation, A Permanent Home

Ocean City observed its centennial in 1979. The Centennial Commission planned activities for residents and visitors of all ages. There were shows and concerts, meetings, sketches and skits, fashion shows, and history lessons. The 100th anniversary of the founding of the city was celebrated all year long. By 1986, after two court cases and a citizen's referendum, the Sunday restrictions prohibiting most retail sales and forms of recreation were lifted. In 2002, a new bridge in the northern end of Ocean City was built to replace the one between Ocean City and Atlantic County, which had opened in 1928. A new high school to replace the one built in 1923 and enlarged over the years was badly needed. Attempts to pass referendums to enlarge the school once again were voted down several times. Finally, in 2001, with a promise of $11.5 million in state aid, a referendum to build a new school, rather than enlarge the old one, was passed. The *Press of Atlantic City* wrote in an editorial the next day, "The Ocean City vote . . . was a referendum on the town character. . . .Voters were really deciding what their city will be: a vacation stop or a living, growing community." The new school, across from the old one, opened in 2004.

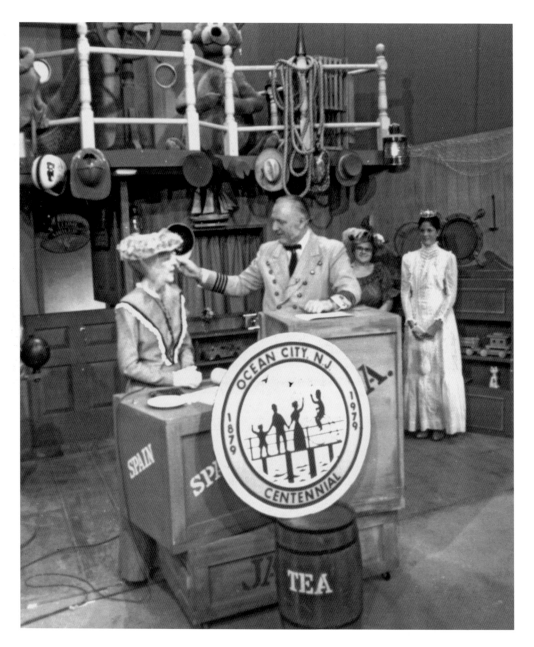

Eleanor Whittaker and Captain Noah

In 1979, Ocean City celebrated its centennial with a full year of events. Whittaker was chairwoman of the Centennial Commission. She had served as chairwoman of the fundraising committee for the Bicentennial Commission and was a member of the Cape May County Bicentennial Commission. She was also a member of the original committee for the annual Flower Show and served as a registrar for many years for the annual Boardwalk Art Show. Ocean City resident Rev. W. Carter Merbrier was Captain Noah to generations of children who watched his television program, *Captain Noah and His Magical Ark,* from 1967 to 1994. In this photograph, Whittaker and Captain Noah participate in a skit during the Centennial Celebration.

Esther Weil
Founder of the *Friends of Music,* who produced over 115 concerts at the Ocean City Music Pier, Weil was herself an accomplished musician. A pianist and teacher, with a beautiful singing voice, she and her husband Paul, a music teacher considered a specialist in junior high vocal music, compiled a songbook designed as a tool for young boys with changing voices. She was a strong supporter of the Ocean City Pops Orchestra, the Ocean City Flower Show, and the Ocean City Arts Center. (Courtesy of Judy Perkins.)

Edna Streaker May
The "Southend Talespinner," May has lived in the far south end of Ocean City since she was a child. Every August, May sets out her approximately 2,000 photographs of Ocean City at the Union Chapel by the Sea and invites the public in to view them. Here May is on the right with Doris Marts, whose father, Al Senior, and husband, Bob Marts, took many of May's pictures. (Courtesy of Edna Streaker May.)

Gillian Family

In 1929, when David Gillian opened the Fun Deck at Plymouth Place and the Boardwalk, he could not have known it was the start of what would become an amusement park dynasty. Gillian was a musician who played with an orchestra at a pier on the boardwalk. After the devastating boardwalk fire of 1927, he decided it was an opportune time to open the Fun Deck. He started with just a Ferris wheel and a carousel and added more rides each summer. His sons, Robert and Roy, took over management of the Fun Deck when he retired in 1957. When the opportunity arose in 1965 for Roy Gillian to buy a vacant lot at Sixth Street and the Boardwalk, he sold his share of the Fun Deck to his brother and opened Wonderland Pier, a colorful pier of amusement rides. By 1977, Robert had decided to retire and sold the Fun Deck back to Roy, whose three sons James, Steven, and Jay took it over. In 1988, the Gillians decided something new was needed, tore down the Fun Deck, and built a state-of-the-art waterpark. They saved one of the original carousel horses, and on David Gillian's 99th birthday, donated it to the Ocean City Historical Museum. In the photograph on this page, taken at the museum, are David Gillian, left, with his son Roy Gillian. (Courtesy of OCHM.)

Roy Gillian (ABOVE RIGHT)

Roy Gillian has been much more than an amusement park owner in Ocean City. He has served as city commissioner, Cape May County Freeholder, and was Ocean City's mayor from 1986 to 1990. He was president of the Ocean City Chamber of Commerce, president of Shore Memorial Hospital's Board of Directors, chairman of the Board of Directors of the Ocean City Home Bank, and president of the International Association of Amusement Parks and Attractions. His wife, Pat, is also involved with civic affairs, serving as chairwoman of the Miss Night in Venice Committee, and other charitable organizations. (Courtesy of Michele and Jay Gillian.)

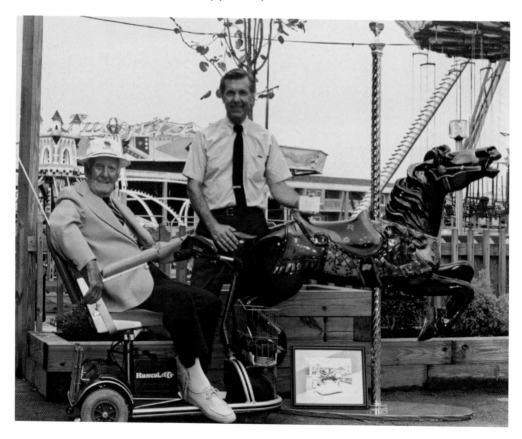

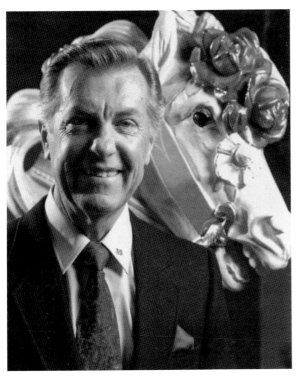

Jay Gillian (BELOW)
Jay Gillian has followed in his father's footsteps. He is the current Ocean City mayor, having been elected to a four-year term in 2010. He was president of the Ocean City Board of Education, chairman of Shore Memorial Hospital's Board of Directors, and is on the board of directors for the Ocean City Historical Museum and First Night Ocean City. His wife, Michele, is the executive director of the Ocean City Regional Chamber of Commerce and is on the board of directors for First Night Ocean City. In the bottom photograph, next page, are Michele and Jay Gillian. (Courtesy of Donald B. Kravitz.)

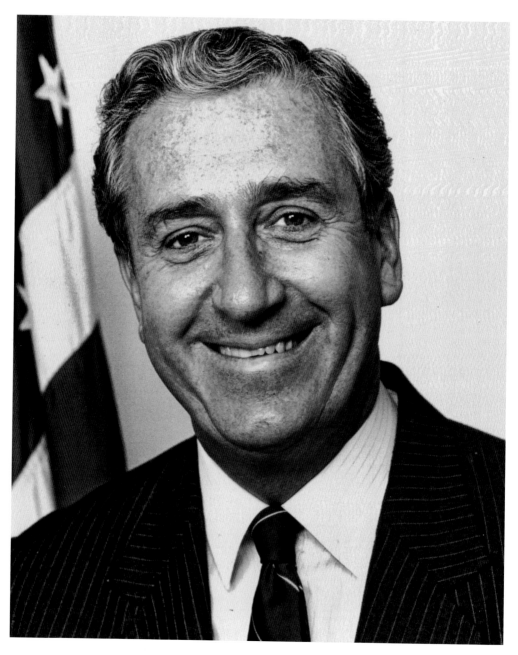

William J. Hughes
Former congressman and ambassador to Panama William J. Hughes has lived near the beach in Ocean City for many years. He made cleaning up the ocean one of his top priorities while in Congress. It took him 14 years to get a law passed making it illegal to dump medical and other waste into the ocean. Since the passage of that bill in 1987, New Jersey's ocean and beaches have slowly recovered.

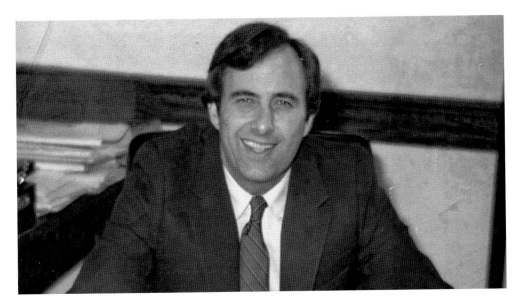

Jack Bittner
Bittner was elected mayor in 1982 and served until 1986. He was the owner of the Sandaway Hotel on Eighth Street and Ocean Avenue and was a former member of the Ocean City Board of Education and of the Cape May County Board of Freeholders.

Rozelia Cobb
Cobb was a special education teacher at Ocean City Intermediate School, but her real job was making a difference in children's lives. Youngsters knew that if they needed a safe haven, her home was always available. A pioneer in the field of special education, she started the city's first program for the perceptually impaired and was named New Jersey's Special Education Teacher of the Year in 1987. She worked for twenty years in the Philadelphia school district and taught special education at Temple University before returning to Ocean City in 1970. She organized an after school club for youngsters who had no one at home when they returned from school, a program she ran for 12 years. Cobb was chairwoman of Ocean City's Affirmative Action Committee and served on the City Council Ethics Committee. Each year a $1,000 scholarship is awarded to an Ocean City High School senior in her honor. She organized the first community-wide celebration of Martin Luther King Day in Ocean City and Cape May County. Shown is the Ocean City Intermediate School where Cobb taught.

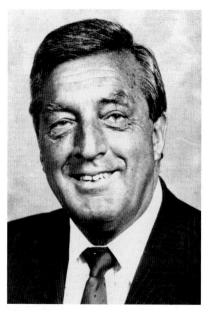

Nicholas J. Trofa Jr.

A lifelong Ocean City resident, Trofa served eight years as a councilman before being elected mayor in 1990. Trofa, less than two years into his term, died of a heart attack on January 31, 1992. There is a plaque on the Music Pier honoring Nicholas "Chick" Trofa Jr. for his service to the community.

Catherine Finnegan

It is certainly not a gossip column, although it appears in the *Ocean City Gazette* every week along with pictures of locals at play. Finnegan began writing her column in the fall of 1983 after Judy Becotte, the former columnist, asked if she would be interested in taking it over. Cathy Finnegan's weekly column includes eight pictures, taken by her, at social events and fundraisers in and around Ocean City. She keeps everyone up to date on what is happening around town. (Courtesy of Cathy Finnegan.)

Frank Longo
Co-winners of the 1985 Grand National Silver Cup Award for craftsmanship in the shoe service industry and the 1991 National Retail Merchant of the Year award, Frank and Carol Longo moved their shoe clinic from the downtown to 1001 Simpson Avenue, in the traditional center of the Italian American community, in 1991. The family has been in the shoe repair industry in Ocean City for 75 years, and Longo is more a shoe therapist than a shoe repairman. (Courtesy of Carol and Frank Longo.)

Edith Callahan
In 1987, Callahan and her husband Joseph moved to Ocean City, and immediately got involved with the community. Callahan was the volunteer coordinator for the Coalition Against Rape and Abuse in 1988, founded the Cape May County Chapter of Mothers Against Drunk Driving in 1991, the Ocean City High School After Prom organization in 1994, and the Ocean City High School Basketball Boosters Club in 1995. (Courtesy of Alice Wolf.)

Raffaele Biamonte

It simply says "Raffaele" on the door of Biamonte's tailor shop, but everyone knows his name. He has had his shop on Asbury Avenue for 43 years, and if you want a tailor-made suit or dress shirt, an evening gown or evening slacks, Raffaele's is where you go. He has designed and made gowns for Miss America contestants, at least two of whom have won the crown wearing his creations. (Courtesy of Raffaele Biamonte.)

Ed Wismer

An artist, writer, and raconteur, Wismer taught art for over 30 years in the Millville, New Jersey, public schools, He is a longtime board member of the Ocean City Arts Center and one of the founders and trustees of Friends of the Pops. His popular weekly columns in the *Ocean City Sentinel* reviewing lectures and productions are always accompanied by one of his illustrations.

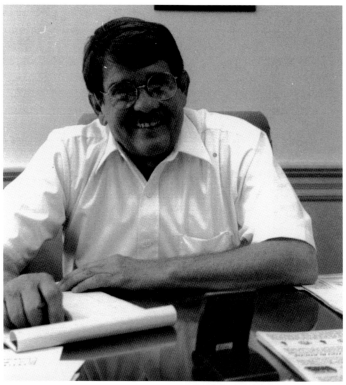

Henry Knight

Henry "Bud" Knight owned Knight's Pharmacy for 27 years. He was known as a pharmacist who would get up in the middle of the night to fill a prescription for a sick child. Knight was elected mayor in 1992 to fill the term of Nicholas Trofa Jr., who had died while in office. He was elected again in 1994, 1998, and 2002. It was while he was mayor that, with his strong support, a successful referendum was held to build a new high school.

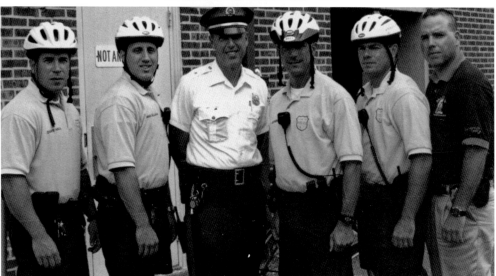

Robert E. Blevin Jr.

On August 30, 1996, Blevin was appointed chief of the Ocean City Police Department. An Ocean City native, he served in the US Marine Corps during the Vietnam War. Blevin joined the police department in 1970. He graduated from the FBI's National Police Academy in 1990. In this 1998 photograph of the Community Oriented Policing (COP) Unit, are, from left to right, officers Dave Hill, Chad Callahan, Blevin, Lt. Jon Werley, Dennis Jones, and Jon Campo.

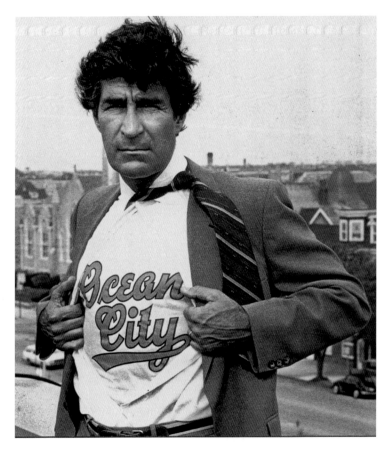

Mark Soifer

Ocean City public relations director Mark Soifer was a partner in a Vineland, New Jersey, advertising agency when he got a postcard from Dr. Marcia Smith telling him Ocean City needed an art show and to call her. Soifer called and the rest is publicity history. It was 1963, B. Thomas Waldman was mayor, and he agreed with Smith: Ocean City needed not only an art show, it needed a public relations director. Thousands of events and 45 years later, Soifer is still at it. Ocean City now has an annual art show, flower show, and craft show as well as its Baby Parade, Night in Venice Parade, First Night Ocean City, Quiet Festival, and numerous other activities which have stretched the summer season into spring and fall. Soifer has had a hand in all of them. Soifer, who makes his home in Vineland with his wife Toby, four children, and eight grandchildren, is a Temple University graduate with a degree in journalism. He is a poet who has written several books. *Cat with Nine Tales*, a book of light verse, includes "A Porgy Named Bess" and other of his poems and songs. Soifer has created events such as May's Martin Z. Mollusk Day, when the hermit crab is brought to the beach to see his shadow and predict when summer will come; and the Doo Dah Parade, which is held every year on the Saturday after April 15, tax day, and includes 500 basset hounds waddling down Asbury Avenue along with people and bands dressed up in zany costumes of their choice, with the only rule being, have fun! Celebrities such as Carol Channing, Mickey Rooney, the Harlem Globetrotters' Meadowlark Lemon, and Soupy Sales have participated in the Doo Dah Parade. There are no limits to Soifer's creativity: his only requirements are that every event be family friendly and that people have fun. His activities have gotten Ocean City publicity from as far away as Japan and the Philippines, are routinely written up in the *New York Times* and other out-of-state newspapers, and have helped Ocean City be named New Jersey's #1 Beach in 2009. (Courtesy of Mark Soifer.)

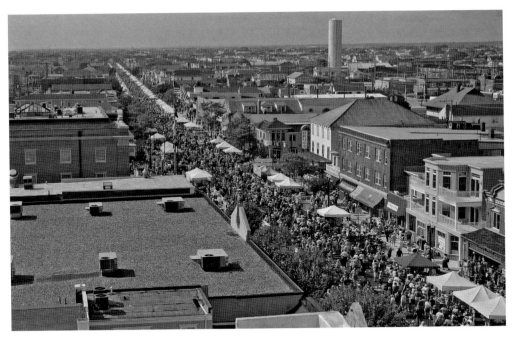

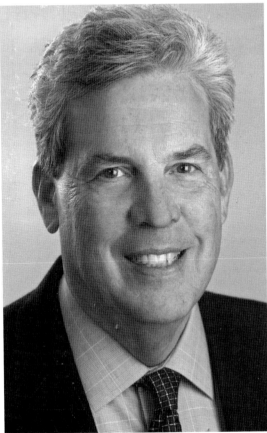

Carolyn Boyd Murphy
An Ocean City native, Murphy was president of the Retail Merchants Association six times. She was the driving force behind the spring and fall block party weekends and other events geared to bringing people into the downtown. In part due to her efforts, Ocean City has one of the most successful downtown shopping areas in Cape May County. This photograph shows the crowd at one of the block parties. (Courtesy of Donald B. Kravitz.)

Richard Deaney
Deaney was Ocean City's business administrator from September 1, 1989, through September 1, 2006. He was appointed to the position by Mayor Roy Gillian. He served in that position for Mayor Nicholas Trofa Jr. and Mayor Henry Knight. Deaney was appointed by city council to fill the office of mayor after Nicholas Trofa Jr. died in office on January 31, 1992, and served until an election was held on May 12, 1992, when he returned to the position of business administrator. (Courtesy of Barbara Deaney.)

Donald B. Kravitz

Kravitz has been Ocean City's photographer since 1988. His images of Ocean City events have been used on the Internet and in newspapers all over the United States and as far away as England, Japan, and the Philippines. Kravitz is also a photographer for Getty Images and is both nationally and internationally known for his images. (Courtesy of Donald B. Kravitz.)

Stuart Sirott

A builder by trade but a volunteer at heart, Sirott was president of the Ocean City Exchange Club from 1988 to 1989. He was one of the founders of the Exchange Club Family Center for the Prevention of Child Abuse and president of that organization from 1999 to 2008. He is the youth protection officer for Rotary International's Youth Exchange Program, and a member of Ocean City's Housing Authority Board. Always ready to show off his red Corvette, Sirott is often called upon to drive in Ocean City's parades. (Courtesy of Donald B. Kravitz.)

Robert Harbaugh
Bob's Restaurant at 14th Street and the Boardwalk celebrated 75 years in business in 2003. Harbaugh, owner of Bob's, was a champion rower for the Ocean City Beach Patrol during the late 1940s and early 1950s and was inducted into their Hall of Fame in 1986. The walls of his restaurant are covered in pictures of the local lifeguards and a plaque with the names of all 80 members of the Hall of Fame. In this photograph, Ocean City Beach Patrol alumnus Chester Derr Jr., left, presents Harbaugh with the 2000 lifeguard squad picture.

Angela and Donald Pileggi
In 2004, when Angela Pileggi retired after 32 years as Ocean City's city clerk, the Baby Parade committee named her grand marshal of the parade. Her husband Donald had retired a few years earlier, after 30 years as Ocean City's recreation director. The person driving the car is unidentified.

Daniel Murray
In 1890, the Methodist Episcopal Church was built at Eighth Street and Central Avenue, the first church built in Ocean City. In 1908, to make way for a larger building, it was moved to Eighth Street and West Avenue and renamed the Tabernacle Baptist Church. In 1999, retired builder Daniel Murray spearheaded a group that raised $415,000 to renovate the church. Murray stands in the sanctuary in this photograph, taken January 18, 2004, at the first Martin Luther King Day celebration held there. (Courtesy of Donald B. Kravitz.)

Ted Prior
Singing "You Ain't Nothin' But a Hound Dog" to this hound dog, Elvis Presley tribute performer Ted Prior was in his element. A noted musician, Prior performed as Elvis in many of Ocean City's special events, including First Night Ocean City and the world famous Baby Parade. His El-Live Show was known throughout South Jersey. Prior also performed with the band Early Morning Reign. (Courtesy of Donald B. Kravitz.)

Donald E. Dearborn
Dearborn took over the duties as superintendent of the Ocean City public schools on October 19, 1992. He continued in that position until June 30, 2005. During his years here, perhaps the most important achievement for the community was the passing of a bond referendum to build a new high school. The school was completed in 2004. (Courtesy of David Nahan.)

Gregory Johnson Sr.
Reverend Johnson was the first African American to be elected president of the Ocean City Board of Education. He had been very active in the referendum to build a new high school, and was president of the school board when ground was broken in 2002 for the new building. By 2004, when the new school opened, Johnson had been elected to city council, the first African American to hold that position. (Courtesy of Donald B. Kravitz.)

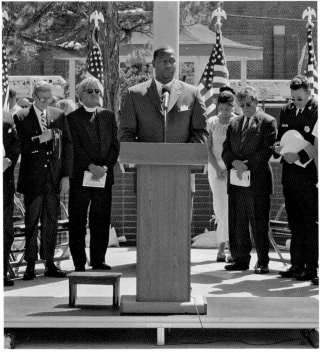

David Nahan
Nahan has been the editor, publisher, and managing partner of the *Ocean City Sentinel* since 1997. Every year, the newspaper wins New Jersey Press Association awards: in 2003, it won five first place awards, including a first place for the editorial pages; in 2010 it received seven. Nahan is the newspaper's photographer for most of the local sports and lifeguard events. He is also the treasurer of the board of directors for the Ocean City Arts Center. (Courtesy of Donald B. Kravitz.)

Steven E. Brady
The Ocean City Home Bank traces its roots back to 1887 and the Ocean City Building and Loan Association. Brady has been president and chief executive officer of Ocean City Home Bank since 1991. He is a member of the Board of Governors of the New Jersey League of Community Bankers. Brady has served on the board of directors of the Ocean City Chamber of Commerce, Business and Neighborhood Development, and First Night Ocean City. (Courtesy of Tricia Ciliberto.)

William Scheible
With the 2011 summer season, Scheible celebrated his 25th year as conductor and musical director of the Ocean City Pops Orchestra. He has brought new, young talent to the concerts as well as stars such as Shirley Jones, Rita Moreno, and Joel Grey. He has taken the Pops to play at the Tabernacle Auditorium and the William and Nancy Hughes Performing Arts Center at the new high school. (Courtesy of Donald B. Kravitz.)

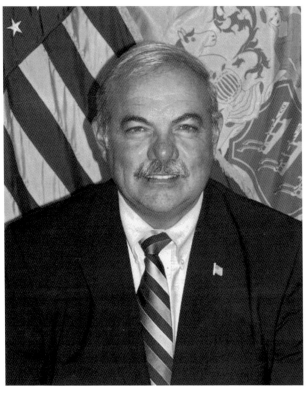

James T. Plousis
Plousis was a member of the Ocean City Police Department from 1978 until 1984, when he was elected Cape May County sheriff. He was reelected for five terms and served in that position until March 25, 2002, when he was sworn in as US marshal for the District of New Jersey. On June 24, 2010, he was confirmed by the New Jersey State Senate as chairman of the State Parole Board. (Courtesy of James T. Plousis.)

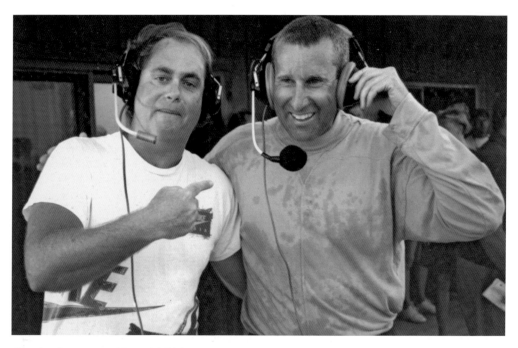

Charles Betson and Ronald Kirk
In this photograph are former Ocean City Beach Patrol member Charles "Chuck" Betson, left, and beach patrol lieutenant Ronald "Ron" Kirk. Betson is interviewing Kirk on the *Betson Connection* after Kirk won the singles rowing event at the 50th annual Margate World War II Memorial Lifeguard Championship race on August 4, 1995. Betson started writing a sports commentary column for the *Press of Atlantic City* in 1980 and continued until 1992. His *Betson Connection* aired on cable television from 1993 to 1998. Betson was the publicity director for the Atlantic City Surf baseball team through 2007. He has had his *Betson Connection* on talk radio since 2007. Kirk is the only active lifeguard to be inducted into the Ocean City Beach Patrol Hall of Fame. Kirk, whose rookie year was 1972, won a South Jersey record 32 intercity championships between 1981 and 1995. He is an Atlantic City High School teacher.

William and Donna Dorney
"Some people do Christmas, I do Night in Venice," says William Dorney, Ocean City lifeguard and summer resident. When he and his wife Donna do it, they do it right! *Saying Goodbye to the Shuttle Atlantis* was the Dorney's winning entry in the 2011 celebration, where the houses on the lagoons as well as the boats in the Night in Venice Parade are decorated for prizes. Dorney stands on his roof putting on the finishing touches. The Dorney's 18th Street lagoon home wins first place in their division every year. (Courtesy of Donald B. Kravitz.)

Margaret Lloyd
Margaret "Peggy" Lloyd has been active in the arts and music communities of Ocean City for over three decades. The 98-year-old Lloyd has been vice president of the Ocean City Arts Center for more than 30 years and a longtime member of the Ocean City Pops advisory board. She grew up in nearby Atlantic City and moved here in 1970. Her goal in life is to inspire children with a love for the arts. Lloyd inspires all who know her with a love for life. (Courtesy of Donald B. Kravitz.)

INDEX

AN IMPRINT OF ARCADIA PUBLISHING

Find more books like this at
www.legendarylocals.com

Discover more local and regional history books at
www.arcadiapublishing.com